Pablo
PICASSO

AN INTRODUCTION

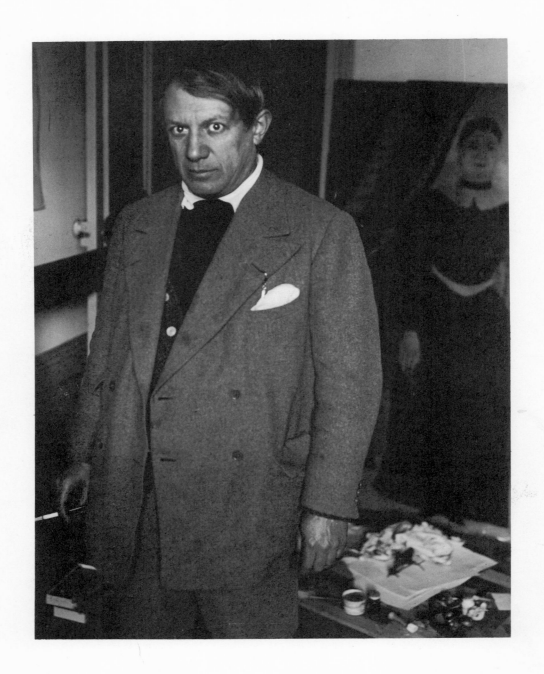

Pablo
PICASSO
AN INTRODUCTION

by Howard Greenfeld

Illustrated with reproductions of the artist's work
in color and black and white

FOLLETT PUBLISHING COMPANY
Chicago

To Peter Hyun, in gratitude

Library of Congress Catalog Card Number: 70-118928

ISBN 0 695-80139-2 Trade Binding

First Printing

Frontispiece: Picasso in Paris, 1932. Photo by Brassaï
from Rapho Guillumette.
Page 175, photo by Charles Uht, New York.

LIST OF ILLUSTRATIONS

Introduction

Picasso is so well known, so widely recognized as the greatest artist of the twentieth century, that it hardly seems necessary to write another book about him. Since 1945, one book every two months has been published about this astounding genius.

Yet fame does not mean knowledge, and Picasso's enormous fame does not mean that he is understood or accepted. For this reason, this short book is an introduction, an attempt to explain just why this man has met with such

astonishing success, just what it is that sets him apart from the other artists of the century.

The first part of this book is an outline of Picasso's early years, his childhood, and his adolescence. In these formative years it is possible to search for clues which might lead to unraveling the mystery of his genius. His family, his education, his early struggles—all these can be helpful in understanding what was to happen. But this is not a study of Picasso the man—the moody Spaniard with hypnotic eyes, intense, difficult, filled with a love of life and an unequalled vitality. It is a study of Picasso the artist, and the second half of this volume traces his development as such. An enormous amount is left out, but enough of the high points of this artist's extraordinarily long and prolific career are examined to support the argument that he might, indeed, be the greatest artist of all time.

PART ONE
THE FORMATION OF
THE PAINTER

I

THE FIRST YEARS

1881

Pablo Picasso was born in Malaga, a sun-drenched seaport on Spain's Mediterranean coast. Malaga is in Andalusia, the most fertile region of Spain. It is a land of rich valleys, of olive trees and cattle and white horses and almonds and oranges. The home of flamenco, the passionate, rhythmic, hand-clapping, foot-stamping music. The home, too, of a proud and distinguished people: long sideburns, short jackets, narrow trousers conventionally identify them.

Andalusians are said to be lighthearted, pleasure-loving, and full of an ironic sense of humor. Their pleasures are both peaceful, as in their leisurely evening strolls through the town streets and squares, and violent: they are fervent aficionados of the bullfight.

Wine and music; bullfights and guitars. Pride.

Pablo Picasso, an Andalusian, was born at midnight, or at 9:30 P.M. or at 11:15 P.M., on October 25, 1881. The exact time of his birth is, of course, of no importance —though astrologers have tried to use this data in determining the reasons behind Picasso's genius—and is only an indication of the enormous amount of study that has gone into each detail of Picasso's life. In any case, it was a dramatic birth: the midwife, mistakenly judging the child to be stillborn, left it for dead on a table in order to care for the mother. Only the presence of an experienced doctor, the uncle Don Salvador, saved the newborn child from suffocation.

The infant was given many first names, as was the custom in Malaga: Pablo, Diego, José, Francisco de Paula, Nepomuceno, Crispiani de la Santissima Trinidad. The origins of his last name come from Spanish tradition, whereby a child takes two last names: first that of his father and then that of his mother. His father was José Ruiz Blasco, and his mother, Maria Picasso Lopez. Thus, the child's last name was Ruiz Picasso. Only several years later did he adopt the single last name of Picasso, Ruiz being too common a name in Spain.

In searching for possible sources of the genius of Picasso, it is customary to turn first to his ancestors—especially his parents and his maternal grandmother, who lived with them. Picasso's grandmother was a woman with an extraordinary imagination, a born storyteller. Her daughter was warm, vivacious, and witty, but a woman who knew when to keep quiet. She understood and valued the gifts of love and friendship, above all. She adored her son; her devotion to her child Pablo was strong and was to remain so all her life. From her he inherited his two outstanding physical traits—his deep black, flashing, penetrating eyes, and his small and sensitive but strong and unusually well-shaped hands.

Picasso's father came from a family whose main characteristics were devotion, tenacity, appreciation of the arts, and sincerity in religion. His physical appearance contrasted greatly with that of his wife. Tall and thin, with reddish hair, his distinguished reserve caused him to be called "the Englishman" by his friends. He appreciated English customs and design.

By profession, José Ruiz Blasco was a painter, though not a very successful one. To sell his work was a struggle, and to increase his income he was forced to go out after commissions. Finally, after his marriage, his responsibilities grew: into his home moved two unmarried sisters and his mother-in-law. By the time Pablo, his first child, was born, he had been forced to take a post as drawing teacher in the Escuela de Artes y Oficios (School of Fine Arts and Crafts) of San Telmo. To further supplement his income,

he took up the boring duties of curator in the Municipal Museum, in charge of the restoration of damaged or deteriorated paintings. His only peace and satisfaction came from the painting he could do in the small restoration studio at the museum. It was in this studio that he pursued his painting; the results were unfortunately not outstanding. Several years later Picasso himself described his father's painting to his lifelong friend Jaime Sabartés: "My father used to paint 'dining room' pictures, the kind with partridges and pigeons, hares and rabbits. . . . His specialty was fowls and flowers. Especially pigeons and lilies. Lilies and pigeons. He also painted other animals, for example, a vixen. . . . Once he made an enormous picture of a dovecote swarming with pigeons."

These pigeons and doves were to become a recurring theme in young Picasso's work.

If his father was a mediocre painter, he was nevertheless able to instill a love of painting into his son, as well as an awareness of the infinite possibilities of using every conceivable material for his art. In his painting José Ruiz Blasco used not only a paintbrush and paints, but scissors, paste, knives, and pins as well, as his son was to do many years later.

Young Pablo could draw before he could talk. For hours he would make drawings in the sand on the square in front of their home. And his first word was *"piz,"* short for the Spanish word *"lápiz,"* pencil.

The Picasso home was close to a neighborhood which the inhabitants would call *"Chupa y Tira"* (Suck and

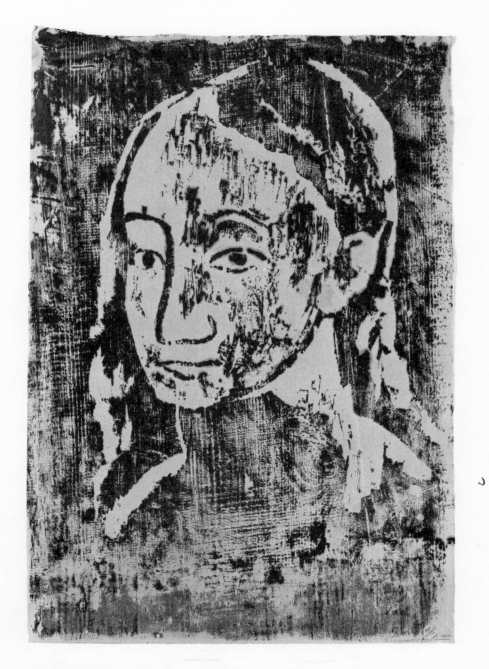

Bust of a Young Girl, 1933. (Woodcut.) Courtesy of The Art
Institute of Chicago

Throw). The reason was explained to Sabartés by Picasso: "The people were so poor that all they could eat was a chowder made with clams. And all their backyards were filled with clamshells which they had thrown out of their windows after having sucked out of them their very souls."

The life of the Picasso family became increasingly difficult as the family grew: three years after Pablo was born saw the birth of a sister, Lola. Then, three years later, a second sister, Conchita. Don José was responsible for his three children, his wife, his own two unmarried sisters, and his wife's mother. To increase his income he gave private lessons in addition to his duties at the museum and at the school. But there were few pupils, and the family was fortunate to have as a landlord a man who would often accept paintings in lieu of rent.

Don José was a devoted father. Whenever possible, he took the boy on long walks through the town and on visits to friends and neighbors. But most enjoyable for the child were the bullfights to which his father would take him on Sunday afternoons. The pageantry and drama, the bright costumes and displays of courage and pride appealed strongly to young Pablo, as they do to most Spanish children.

The only information about Pablo's schooling in Malaga is based on what Sabartés has been told by Picasso. The idea of school did not appeal to the young boy, and he was not unhappy when illness prevented his staying at the public school to which he was first sent. The school

was damp and thoroughly unpleasant; the doctor said the boy's health was being affected, and he was allowed to leave school. But to his dismay, this was not to be the end of his education. A friend of the family was headmaster of the best private school in Malaga, and through him Pablo was admitted.

Though the new school was modern and clean and bright, the young boy was still unenthusiastic; he found every possible excuse not to attend classes. It is true that he was not a very healthy child, but pretended illness accounted for a good many of his absences from school.

Don José accompanied his son to school in the morning, since the school was on the way to the museum where he worked. With him he usually carried a walking stick and his brushes; often too he brought along a pigeon which he would use as a model. These three objects—stick, brushes, and pigeon—were essential to his father so Pablo, to make sure his father would return for him at one o'clock each day, would beg him to leave all or one of them with him in school; in that way he would be sure his father would return for him. Since that seemed to be the only way to get Pablo to enter the classroom, he would usually enter carrying a pigeon or holding onto a walking stick.

Once in the classroom, he was distracted; the lessons did not interest him and, without asking permission, he would often leave his lessons to go to visit the headmaster's wife, a friend of the family who tolerated these visits. There he would calmly and sweetly watch her make a fire

or cook; he felt at home. It was just as useful as sitting absentmindedly in the classroom, thinking of nothing but one o'clock.

Pablo's parents were indulgent; they knew their son was not stupid, but they realized they could not force a formal education onto him. They did insist that he try, that he continue to attend school, and they even went so far as to get him a private tutor, but the results were negligible. The only lessons the boy really enjoyed were his father's drawing lessons.

By 1891, when young Pablo was nine years old, Don José, depressed, saw that he had to abandon the exhausting and frustrating struggle in Malaga. As much as he loved his native town, he simply could not make enough money to support his family properly. So it was that he accepted an appointment as teacher in the Instituto da Guarda in Corunna, a seaport town on the Atlantic in the north of Spain. In every way, he feared, this would be an enormous change from the Mediterranean warmth of Malaga.

Before leaving Malaga, Don José had to face the problem of having Pablo admitted to a school in Corunna. He knew no one in the northern school who could help, so he arranged to have his son take the entrance exam for the Corunna school in Malaga, where it could be administered by a personal friend. But the young boy was hopeless, even unable to add up a column of figures which the teacher had written on the blackboard. Fortunately the answer was written on a piece of paper lying on the teacher's desk, perhaps intentionally, so young Pablo

18

passed his "exam." And even then the numbers meant for him only figures that could be applied in a drawing. As Gertrude Stein wrote many years later, "Picasso wrote painting as other children wrote their 'a b c.' "

In September 1891, shortly before Pablo's tenth birthday, the family dejectedly left for Corunna. They were to travel the whole way by sea, but after a while on board ship they were so worn out and seasick that they left the boat at Vigo and continued the rest of the way to Corunna by train.

The arrival at Corunna confirmed Don José's fears, and the contrast between the cold, wet, and dismal town on the Atlantic and his native sunny Malaga was marked. Corunna's main attraction was its lively seaport. But life there was comparatively joyless, and the wind and rain literally dampened the spirit of its inhabitants.

Don José took up his duties at the school without enthusiasm. He felt himself completely cut off from his youth, his friends, and his roots. Things worsened a few months after the family's arrival in Corunna; the youngest child, Conchita, died of diptheria. All seemed hopeless, and Don José's life settled into a dull routine. His only activity outside the home was his work at the school. At home, he painted a little and spent the rest of his time watching the almost never-ending rain through the windowpanes.

However, real satisfaction came from seeing his little son's astounding progress as an artist. Though the child found it impossible to study reading and writing and arith-

moved to Corunna at age of 10

19

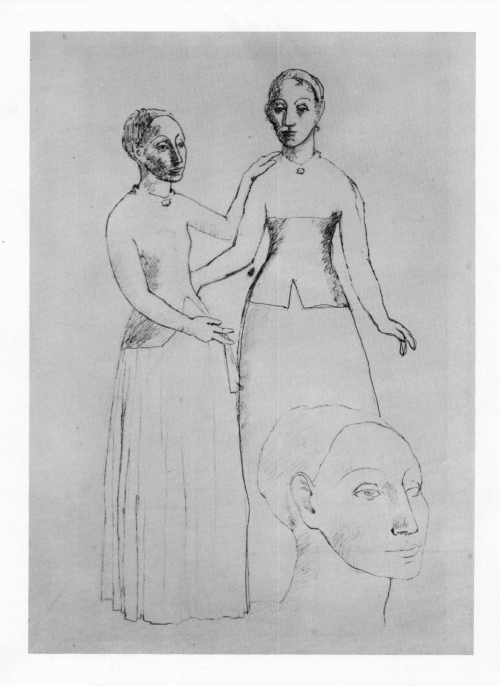

Peasant Girls From Andorra, 1906. (Pen and ink.) Courtesy of
The Art Institute of Chicago

20

metic, he took endless pleasure in studying drawing and painting under his father's warm and patient tutelage. With remarkable speed he mastered every technique taught to him. He learned to do charcoal drawings, skilfully applying the effects of shading necessary for their success. He did drawings from those plaster casts which are used as subjects to be copied by art-school students. And he painted with a talent almost incredible in so young a child, his subjects being ordinary people—a beggar in a cap, or a barefooted young girl. In addition, he did many drawings of his sister Lola as well as portraits of friends of his father. The likenesses are extraordinary. The entire range and feeling of the young boy's work is remarkable when one realizes that he had never seen paintings outside the two provincial cities in which he had lived and had never visited any of the world's great museums.

Young Pablo showed his artistic skills in another way while in Corunna. He wanted to keep his family and friends in Malaga informed of his life in the northwestern city, yet he hated to write letters. So, instead, he communicated with them in the form of newspapers which he invented. The newspapers had two titles: *La Corunna* and *Azul y Blanco* (Blue and White). The format was an ordinary page of paper, folded in half, thus allowing for four pages per newspaper. Since words failed him most of the time, the newspapers were full of drawings; and underneath each, a caption. There are many amusing examples, which describe better than words could the daily life at Corunna. A favorite topic was weather, and one

drawing shows a group of people in the rain, covered by umbrellas. The caption reads: "The rainy season has already begun. It will continue until summer." Another drawing represents skirts being blown in the wind, and the caption reads: "The wind also has begun, and will continue until no Corunna is left."

The paper too had, as all papers should, an advertising section, but there was only one ad. It read: "Wanted to purchase: Thoroughbred pigeons. Address 14 Payo Gomez Street, second floor." The address, of course, was that of Pablo Ruiz Picasso.

Pigeons were, indeed, about all that Don José continued to paint. One day in 1894 he finished half the work on a pigeon and left the rest of the job to be finished by Pablo, who had often assisted him. He then went for one of his rare strolls through town. When he returned, Pablo had finished the painting. The pigeon was so lifelike and accurate that it surpassed anything that the father could have done. Thus, the story goes, Don José handed his palette, brush, and paints to young Pablo, vowing never to paint again. His son would take over and go far beyond anything he himself could accomplish.

In 1895, after four years in Corunna, Don José was offered the opportunity he had hoped for. A professor in the School of Fine Arts in Barcelona was willing to exchange his post for Don José's. After that exchange was made, Don José was told that a second exchange could be brought about which would enable him to go to Majorca, at that time a quiet island with a gentle climate. This

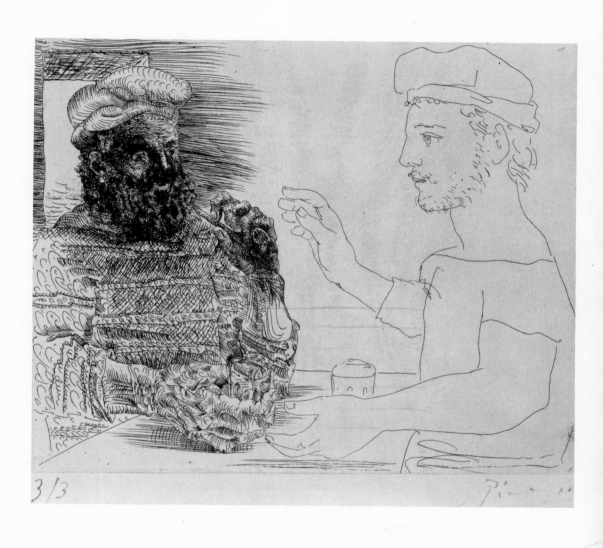

Two Catalan Men, 1933. (Etching.) Courtesy of The Art
Institute of Chicago

second exchange never came about, but Don José was nonetheless pleased to go to Barcelona, and to once more be on the warm Mediterranean.

Before the family left Corunna, young Pablo had his first one-man show—in the doorway of an umbrella maker's shop. Sales were few; who wanted to buy the works of a fourteen-year-old? However, the extraordinary thing was that the work of this young boy had never borne the marks of a child painter. Commenting many years later to his photographer friend Brassaï on the "genius of childhood," Picasso said: "I didn't have this genius. My first drawings could never be exhibited in an exposition of children's drawings. The awkwardness and naïveté of childhood were almost absent from them. I outgrew the period of that marvellous vision very rapidly."

In the summer of 1895, before going to live in Barcelona, the family went to visit their relatives and friends in Malaga. Most important, on the way, they stopped in Madrid, Spain's capital, where young Pablo had a chance to see the Prado, one of the world's great museums, with its magnificent collection of Goya and Velázquez. It was the boy's first direct exposure to the art of these masters.

Pablo's return to Malaga was a triumph. His achievements as an artist in Corunna were looked upon with pride by the entire family. The boy continued to paint members of his family, as well as models found for him by his uncle Salvador. Even young Pablo's games, with which he delighted his younger cousins, involved his creative skill. With one continuous line, he would quickly sketch ani-

mals, birds, or people. And to further entertain, he would rapidly cut figures of horses, or doves, or other animals out of pieces of paper. None of his family doubted that someday the world would appreciate the extraordinary talent of this intense, dynamic boy who could so well express himself in the creation of forms and shapes.

2

BARCELONA

The Ruiz family arrived in Barcelona in September, 1895, just before Pablo's fourteenth birthday. Barcelona was to change his life. After years of growing up under the kind and gentle supervision and indulgent attitude of his parents, he was to enter maturity in that sunny Mediterranean port town, Spain's gateway to the rest of the world.

Barcelona is the capital of Catalonia, a section of Spain so independent that it has even proudly retained its own language. In 1895, it was the industrial center of Spain,

with a population of over half a million. Vitality, toughness, and a sense of individuality characterized the city. The people of Barcelona were drawn to anarchism, a system which regards the absence of all direct, centralized government as the ideal. It exalts personal liberty as the goal for all citizens. The people of Catalonia wanted, for the most part, autonomy under the Spanish state.

During the time Picasso was in Barcelona—he lived there on and off for nine years—the city was in a state of ferment. Not only politically, but also culturally, it was the most progressive city in Spain. Its artists and writers and poets looked away from Spain for their inspiration. The words one heard were Art Nouveau, Paris, Impressionism, and Symbolism. Everything new and different was sympathetically considered. The works of El Greco, for years unpopular in Spain, were revived in Barcelona. Artists from France, their works either seen through reproduction or reported on by those Spaniards who went to Paris, had great success, above all Toulouse-Lautrec, and Steinlen, a Swiss painter who lived in Paris. The Symbolists—Odilon Redon, Gustave Moreau—and the Impressionists, too, were highly praised in Barcelona at the end of the century.

The death of Louis Pasteur, the French chemist and bacteriologist, drew much attention in the press, reminding Catalans of the progress that had been made in the field of science. Sarah Bernhardt, the great French actress, came to perform in Barcelona. And in other theaters, the people could see some startling creations of northern Europe:

27

notably, Ibsen's *Ghosts* and a play by the melancholic Belgian, Maurice Maeterlinck.

The political news of the moment was the disastrous colonial war being waged in Cuba. From that land desperate and weary soldiers and refugees returned, adding to the spirit of general social unrest, a need for a change in the traditional, established order.

During Picasso's stay in Barcelona, bomb explosions, protests against the government, rocked the city on various occasions. A bomb had exploded in the opera house; later one was to explode on the street named Calle de Cambios Nuevos, killing seven people. It was a time of violence and self-assertion.

This same spirit invaded the arts during those last years of the nineteenth century. There was an obsession with everything that came from the north—particularly from Germany, England, or France. Performances of the works of Richard Wagner—especially *Tristan and Isolde* and *Siegfried*—reflected the interest in German romanticism. Translations of the works of the pessimistic German philosopher Arthur Schopenhauer appeared and were avidly discussed. An anarchist paper, *Ciencia Social*, published cartoons of social protest by Honoré Daumier, and works of social realism by the French painters Courbet and Millet. Also published were translations of the idealist works of Leo Tolstoy.

A great number of Spanish intellectuals had been to England. They saw to it that Spanish versions of the works of John Ruskin and the pre-Raphaelites were made

available. English illustrations too had a vogue in Barcelona. The works of James Whistler, the American artist who painted in England, were well thought of, as were the fantastic works of Aubrey Beardsley. Kate Greenaway and Arthur Rackham, both famous for their illustrations of children's books, were highly respected.

But perhaps most important as an influence were the writings of Friedrich Nietzsche, the German poet and philosopher. It was his works that told of the coming of a glorious new art, and the emergence of a new type of artist in the twentieth century.

Pablo Picasso, who would one day revolutionize art, arrived in Barcelona with his family in September. On October 25, his fourteenth birthday, the headlines announced a spectacular train crash at the Montparnasse station in Paris. A train had roared at full speed into the station and crashed down into the street, two floors below. This terrifying news was to symbolize both the progress into which the twentieth century was heading, and the fear of the unknown that this progress inspired.

Soon after the Ruiz family arrived they found rooms near Barcelona's port—and their beloved Mediterranean—and very near the railroad station from which trains left for France. It was to be in every way an opening onto another world.

Don José immediately took up his position at the Lonja, the Academy of Fine Arts. His work there was

much the same as it had been at Corunna, but he preferred the sun of Barcelona and the opportunities the city's wide streets gave him to stroll about in his off hours. Especially pleasing were the walks along the Ramblas, wide boulevards lined with flower stalls and cages filled with rare pigeons. But, for him Barcelona could still not compare to Malaga. He missed the leisurely pace of his hometown, and found the people of Barcelona far too excited and businesslike. In addition, they spoke a Catalan language quite different from his own Spanish.

One of Don José's first tasks was to have his son enrolled in the Lonja, where he could continue his studies. A three-part entrance examination was necessary. The first consisted of making a copy from an existing print or drawing; the second required the applicant to copy from a plaster figure; and the third involved drawing from a live model. It is probable that because of his position at the school Don José was able to have Pablo exempted from the first two tests. For the third, too, an exception had to be made, for rules stated that the prospective student had to be at least twenty years old. Legend has had it that young Pablo passed his examination in one day; most students were allowed a month to complete it. Recent discoveries, however, disprove this, as drawings of the model exist, dated several days apart. Nonetheless, Pablo easily passed the examination, certainly in far less than the time allotted, and entered the Lonja.

There was, however, little that the enormously talented boy could learn at the strict, traditional art school; it

was already necessary for him to go beyond the mere conventions of the day. Perhaps the best thing that happened to him at that rigid school was the beginning of his friendship with Manuel Pallarés, who was to play an important part in his life. Pallarés was five years older than Picasso; he lived alone in the city and the Ruiz family welcomed him as a good influence on their young son.

Though Pablo received little benefit from his schooling, he continued to work as always. It was then, as it was always to be, inconceivable that he should pass a day without drawing or painting. His subjects came from Barcelona itself, its parks, winding streets, its people. He would wander around the old section, finding inspiration wherever he went. In addition, he used his own family as models. Many of these pictures survive today and give eloquent testimony to the young boy's precocious skills.

The first year in Barcelona passed quickly, with Pablo receiving great pleasure and stimulus from the city and from his new friends, especially Pallarés, but little gain from the art school. To please his father, nonetheless, he enrolled in the Lonja for a second year. However, he rarely attended it, and when he did it was only to make use of the models provided by the school.

Don José, a traditionalist, did not agree with his son's attempts to break away from academic training. However, he did most certainly recognize the boy's unusual ability and rewarded him with a studio of his own. Here Pablo could work undisturbed, or almost undisturbed, for the studio was between his family's home and

the art school, so that Don José could easily stop by on his way to work.

It was here that Pablo painted a work that was to bring him some degree of recognition. It is called *Science and Charity*; it clearly shows the influence of Don José, both in subject matter and style. It is a large picture, showing a doctor taking the pulse of a bedridden woman; on the other side of the bed stands a nun, a child in her arm, who is offering a cup to the sick woman. It is not a distinguished work by today's standards, but it is a work of remarkable competence, especially in view of the painter's age. This painting, clearly a work done to please Don José—who was also the model for the doctor—was entered in a competition at the National Fine Arts Exhibition at Madrid, and there it won an honorable mention in 1897. Later, at the Provincial Exhibition at Malaga, it won for the artist a gold medal.

Shortly after painting *Science and Charity*, the young boy—he was still only fifteen—seemed to find a new freedom. He allowed his art to expand, and to be influenced by new forces, among them the social cartoons of Daumier, whose work he had seen in reproduction. The short period of submission to his father and to the needs of academies had come to an end.

In the summer of 1897, the family went home to Malaga for a holiday. There was great rejoicing at their return, and even greater pride at the achievements of the young painter. He would, they hoped, follow a regular

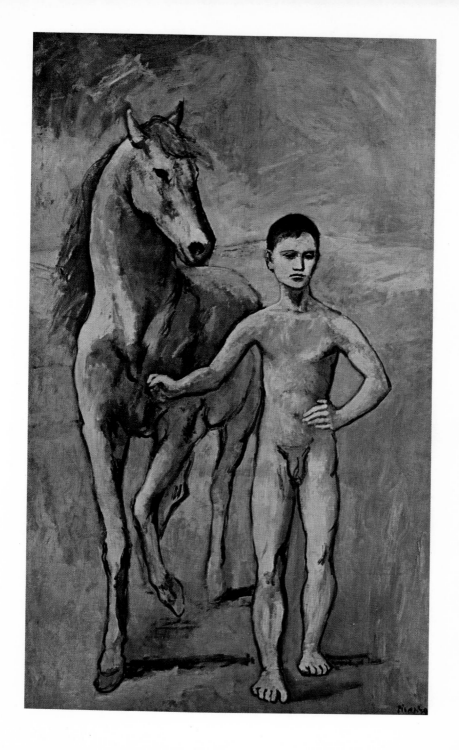

Daniel-Henry Kahnweiler, 1910. (Oil on canvas.) Courtesy of
The Art Institute of Chicago

36

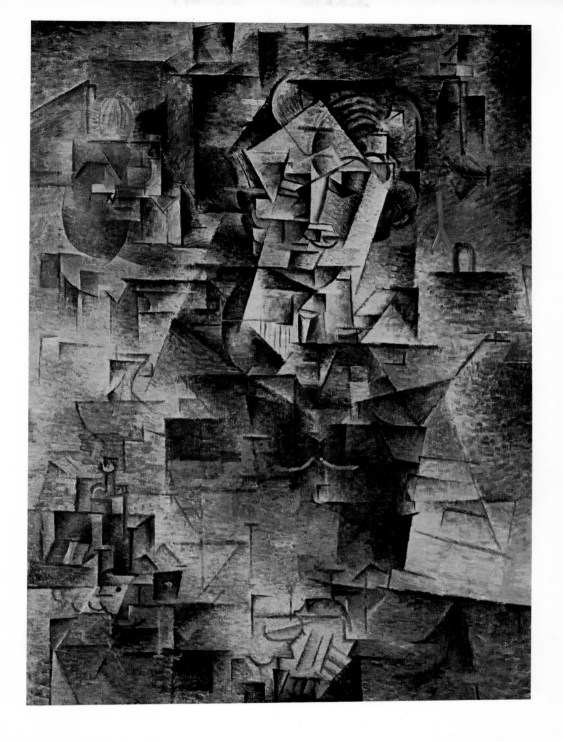

The Accordionist, 1911. (Oil on canvas.) Courtesy of The
Solomon R. Guggenheim Museum, New York City

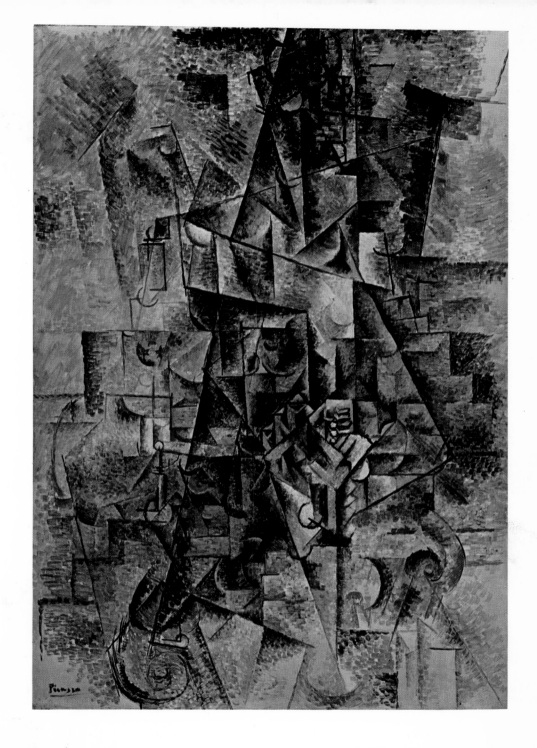

39

path and become the man they had wanted, a convention-ally successful painter of Malaga.

But at the end of the summer, Picasso disappointed his family by saying that he was not planning to stay in Malaga and that he was not even planning to return to Barcelona. Instead, he would go to Madrid, living off a small allowance from his uncle, to see what Spain's capital had to offer him. In this way, too, he would liberate him-self from the protection of his family. He had to act on his own; he had taken from that background and tutelage all that it could offer him. He could undoubtedly have comfortably gone along the path his family had chosen and become an outstanding traditional painter; but this was not to be his way. A pattern—the rejection of all he had mastered in exchange for new paths—which he was to follow all his life was being established.

Picasso's stay in Madrid was not a successful one. Upon his arrival, he took the entrance exams for the Royal Academy of San Fernando, and again passed brilliantly. However, as had happened before, there was nothing he could learn from the professors at the academy. In com-pensation, though, there was much to learn from the magnificent paintings of Goya and Velázquez which adorned the academy's gallery. Then too there was the Prado, where the young painter could see and study some of the greatest of all paintings. The city too fascinated him, its people full of vitality in spite of the enormous poverty. It was here too that Picasso personally suffered

real poverty for the first time. His uncle in Malaga, disappointed that the boy was not following the proper academic ways, cut off his allowance, and Pablo had to live on the smaller sum that his father was able to give him. There was not enough money for food; even worse for Pablo, there was not enough money to buy the right materials for his painting.

In June 1898, worn out and sick—he had suffered from scarlet fever in Madrid—he returned to Barcelona. Once there his friend Manuel Pallarés convinced him to join him in a visit to Pallarés' family, in Horta de Ebro, a village, in the province of Tarragona, now known as Horta de San Juan.

Many years later, Picasso said: "Everything I know I learned in Horta de Ebro." For that reason, it is interesting to examine somewhat closely just what this young painter did during the several months spent in the small village.

Above all, this period meant his first contact with rural living, among hard-working peasants whose tasks he learned to perform himself. It was to be his first confrontation with the strength and beauty of nature, a totally new way of life.

Pallarés and Picasso took the train from Barcelona as far as the town of Tortosa, to the south. There they were met by Pallarés' older brother—with two mules, which they took turns riding to the village.

Horta de Ebro, a village of white stone houses built on a hill, lies near the Ebro River. It is surrounded by

limestone mountains and fertile vine- and olive-covered hills. All is baked in the hot sun, and when the heat became too great, Picasso and his friend would spend days exploring the surrounding mountains. They wanted not only to escape the village heat, but also to live in the midst of nature itself. At one point they found a mountain cave in which they stayed several weeks. They were accompanied on the first part of this expedition by Salvador, Pallarés' younger brother, who led a mule laden with provisions for living and for painting. When it became difficult to go further with the mule, the two friends, paraphernalia on their backs, continued to climb by foot. Once installed in the cave, which was nothing more than a huge protruding rock, they made their beds of straw and grass. They set up their painting equipment and painted face to face with nature. The many-shaped trees, the mountains, the passing shepherds, all inspired Picasso to paint subjects he had never treated before. The days were idyllic; food came from a nearby farm and in the evening the two boys would light a big fire, cook their meals, and talk endlessly before going to sleep. Once in a while, Salvador would come to visit, bringing them more provisions and material needed for their painting.

At the end of the summer, the two friends returned to the village. Picasso was once again healthy, stronger than he had ever been. Life in the village, too, suited him, and he did not yet want to return to Barcelona. In Horta de Ebro he enjoyed quietly watching as well as talking to the residents—the farmers, the shoemakers, the locksmiths,

the work-hardened peasants. He learned their skills, learned how to cope with the forces of nature, and shared in the life of the good and simple people. Everything he knows he learned in Horta de Ebro—this includes not only the manual skills acquired there, but also the need for these manual skills and the power of raw nature.

In the spring of 1899, Picasso returned to Barcelona, where another kind of life awaited him, where he was to reach full independence and maturity. He was almost eighteen years old.

3
Toward Maturity

The intellectual life in most European cities germinates from a café or cafés. In Barcelona at the end of the nineteenth century, advanced ideas were discussed and new works of art displayed at a café-beer garden-cabaret called Els 4 Gats—The Four Cats. This café, on a narrow side street, not far from Barcelona's port, had been opened in June 1897. Its name most likely came from a Catalan expression, "We're only four cats," meaning there's almost no one else around. The café was founded by a man

named Pere Romeu. In addition to serving food for the body, the café was meant to enrich and stimulate the minds of its clients. For this function, Ramon Casas and Miguel Utrillo were its literary and artistic "directors." The long walls were covered with paintings by its habitués; on these walls exhibitions of the works of local artists were periodically held, artists of the avant-garde. The Four Cats was a lively, noisy center of the forward-looking, young intellectual life of Barcelona, and Picasso fitted into it perfectly. It was the ideal focal point for his rebellion and his maturation. He was no longer a child, and his freedom began when, refusing to live at the home of his parents, he found his lodgings and studios wherever he could, generally sharing them with other artists.

His social life, however, centered at The Four Cats, which by 1899 had achieved considerable success and even acceptance. Pere Romeu had even established a magazine which published the illustrations of many of the young artists of the period. That magazine, *Els 4 Gats*, was later succeeded by *Pel i Ploma*, directed by Utrillo, which had great impact on the artistic ideas of the time.

Picasso's life was an exciting one, and he flourished in the atmosphere of social upheaval and unrest that stirred Barcelona at the time. His friends were the city's revolutionary artists and writers. He became proficient in their language—Catalan—and joined them in their Sunday afternoon parties, during which all kinds of literary contests were held. These afternoons, too, were the occasions for every sort of experimentation: at one point, the artists,

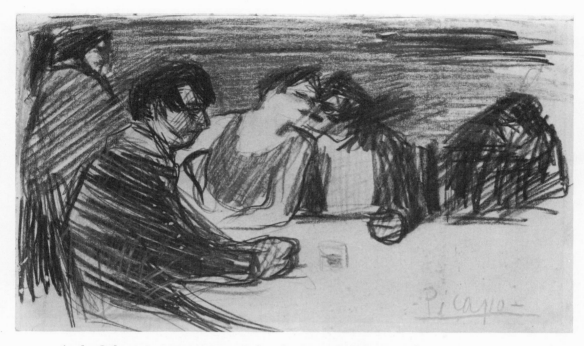

At the Cabaret, ca. 1898-1900. (Colored crayons.) Courtesy of
The Art Institute of Chicago

including Picasso, tried frying their drawings, just as if
they were frying eggs.

In addition to taking part in the stimulation that group
life in Barcelona had to offer him, he continued to work;
his hands were never at rest, as he constantly used them for
drawing.

During this period, Picasso shared a studio with Carlos
Casagemas, a tall, thin, straggly-looking young painter.
The studio was bare, and to remedy this Picasso created

47

what they didn't have, covering the walls with paintings of imaginary furnishings. There were bookshelves, chairs, cupboards, even fruit and flowers. And to upgrade it even more, the figures of a maid and manservant. Already, all of life was art to the young man.

In February 1900, *Els 4 Gats* held the first Picasso exhibition, and a critic spoke of the young man's "extraordinary facility." This ability to reach perfection with comparative ease was to be a threat to Picasso all his life; it would be a temptation to surrender to it, to use it to perform successfully the commonplace and not go beyond it, but this was not to be Picasso's way. At this time, though this first exhibition of Picasso's portraits drew praise, there were few sales, except to those whose portraits Picasso had painted.

In 1900, the eyes of the world were on Paris, where a gigantic Universal Exposition was being held. The French capital was the artistic center of the world, and most of Barcelona's intellectuals had been there, returning with glowing reports of the city and its art. Casagemas was determined to go to Paris and to persuade his friend Picasso to join him. The latter's family, especially his father, was opposed but eventually they consented, even to the extent of making the great sacrifice of paying for their son's trip. In October 1900, Picasso left Barcelona in an exultant mood. In spite of his lack of commercial success, he felt confident of the future. Just as he left his home, he did a self-portrait: written on his brow three times were the

words: YO EL REY (I THE KING). He had not yet reached his nineteenth birthday.

Once in Paris, the two young men quickly found a studio which they shared with Pallarés, who was also there at the time. The studio was in Montmartre, a villagelike section high on a hill above the city, yet part of it, known for its spirit of independence. The whole of Paris was a revelation to Picasso. He saw for the first time the works of the Impressionists—Monet, Renoir, Pissarro—and those of the Post-Impressionists—Toulouse-Lautrec, Gauguin, and Van Gogh. These latter were especially to influence his work at the time. Important also would be the works he so admired of the earlier French painters, Ingres and Delacroix.

But Picasso was influenced too by the life he saw around him. With his Spanish friends—there were many Spaniards there at the time—he visited the flourishing cafés, music halls, and cabarets. He painted what he saw, and his themes were those of the Impressionists: the streets, mothers and children, parks, flowers. He painted the famous dance hall, the Moulin de la Galette, which Toulouse-Lautrec had done before him.

The young artist had brought samples of his own work to Paris, and one day took them to the small gallery of Berthe Weill. There were only a few galleries in Paris that were friendly to young painters, and this gallery, owned by a courageous little woman, was one of them. Berthe Weill bought three of Picasso's bullfight scenes, but even more important, through her Picasso met a business-

man from Catalonia, Petrus Manach, a man with an eye for painting and a love of it. He was taken with Picasso's work, so much so that he offered his young fellow-countryman a steady income of one hundred and fifty francs per month, in return for which Picasso would turn over to him all his work. This, finally, would give the young painter freedom from the poverty from which he suffered, and he eagerly accepted Manach's offer.

However, this first visit to Paris ended in December, after less than three months. Casagemas was deeply depressed, for the love he felt toward a girl was not being returned, and Picasso thought it would be good for his friend to return to the Spanish sun. Picasso would take him there.

So it was that the two young men left Paris and went to Malaga for Christmas. Picasso, with the excitement of Paris behind him, looked forward to the return home, to once again seeing his birthplace and his family. But shortly after his return, he realized that he could no longer live in his native town. His family was horrified by his appearance: he had long hair which was topped by an artist's hat. The boy had turned into a nonconformist in this society and as such was no longer acceptable. Especially bitter words came from the uncle who had helped him so much in the past. In addition, Casagemas' depression showed no signs of abating, so there seemed to be no reason to stay on.

Madrid was the next stop, and there Picasso saw Casagemas for the last time, for the latter's poor spirits continued, and he returned to Paris where shortly there-

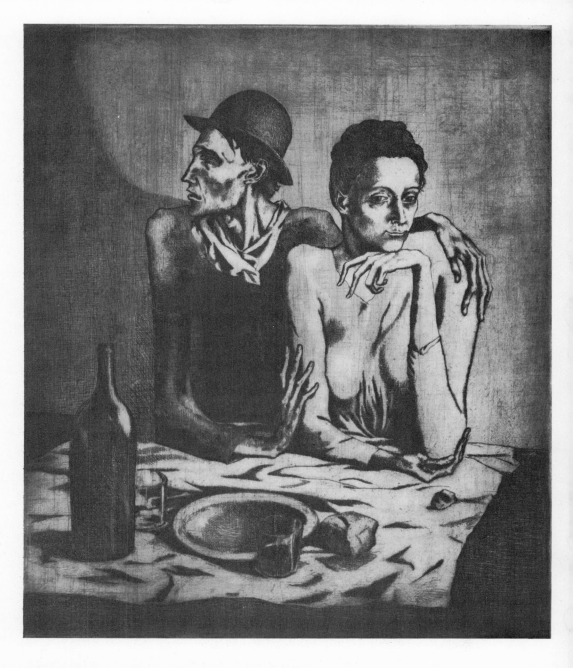

The Frugal Repast, 1904. (Etching on zinc.) Courtesy of The
Art Institute of Chicago

after he committed suicide in a café. This tragedy deeply affected Picasso, as was to be shown in his later works.

Picasso stayed in Madrid from January to the spring of 1901. In the beginning he lived in a boardinghouse, but boardinghouse customs and rules were not at all to his liking, and he immediately began to search for a room of his own. Soon he found it—in a cold, drafty attic, with no heat and no light. His only furniture consisted of a cot with a straw mattress, one table and one chair. As always, he preferred to work at night, but his only light came from a flickering candle which he had stuck in the neck of a bottle.

Picasso persevered; he wanted somehow to get the best out of what he thought would be a year's stay in Madrid. Soon after his arrival there, he met a young writer, also from Barcelona, named Francisco de A. Soler. The two men decided to start a magazine and call it *Arte Joven* (Young Art). Picasso was to be art editor and Soler literary editor. It was a magazine of revolt, a magazine, as the editors boldly announced, not meant to please the middle classes. Its purpose was to inject some of the Catalonian spirit of nonconformity into the relatively conservative spirit of Madrid. *Arte Joven* was filled with Picasso's sketches. In addition, the two editors did their best to gather Madrid's young revolutionary writers together for material for the magazine. But there were financial problems: newsstand sales were not enough, and there were no subscribers. At one point, Picasso solicited the

help of an uncle by sending him a copy of the magazine. The uncle, horrified, refused angrily. Advertisements then seemed to be the answer. An ad was placed for Els 4 Gats, but that, of course, was free. One paid ad was from an electric belt manufacturer—Soler's father was the manufacturer—but that hardly took care of much. *Arte Joven* could not continue.

After its expiration, a new one was announced, but it was never published. Instead, Picasso returned to Barcelona. There an exhibition of his pastels was organized by *Pel i Ploma* at the Sala Pares, one of the city's best galleries. It was a great honor, but Picasso seemed restless and anxious to return to Paris. Among other reasons, Manach was complaining that Picasso was supplying him with none of his paintings and thus not fulfilling his part of the agreement.

In April 1901, Picasso returned to Paris for his second visit. With him he brought a portfolio of drawings for Manach; the latter, delighted, offered to share his sixth-floor apartment with his protégé. He went even further and introduced Picasso to Ambroise Vollard, the city's most daring art dealer. Vollard, then thirty-six years old, had become an art dealer in 1893 and had caused a scandal by holding the largest exhibition of the works of Paul Cézanne at his gallery in 1895. Cézanne's paintings, from which Picasso and countless other painters were to draw inspiration, were considered daring and revolutionary at the time. Vollard, a seemingly gruff man with a biting

sense of humor, had befriended Pissarro, Rodin, Redon, Renoir, Degas, Bonnard, and Toulouse-Lautrec. He was the first dealer to present an exhibition of Matisse: he was the most imaginative dealer of his time, if not of all times. Once again, when he saw the work of the young Spanish artist, his instinct proved correct: he enthusiastically promised Picasso an exhibition to open on June 24, 1901.

Seventy-five works by Picasso were hung at his exhibition. There were scenes of bullfights, of lovers embracing, of night life, the crowds at a racetrack, tranquil groups in the park and cabaret scenes. Many of the themes and subjects were those of Degas and Toulouse-Lautrec, but the colors—violent and clashing, with strong brushstrokes—were influenced by Van Gogh.

The exhibition was commercially a failure, but in addition to the prestige that came from having a show at Vollard's, Picasso was noticed by Felicien Fagus, the critic for *La Gazette d'Art*. Fagus' words were significant in view of what had been said of Picasso's facility in Barcelona: "Picasso is a painter, absolutely and beautifully; his power of divining the substance of things should suffice to prove it. . . . One can easily perceive many a probable influence apart from that of his own great ancestry: Delacroix, Manet, Monet, Van Gogh, Pissarro, Toulouse-Lautrec, Degas, Forain, Rops, others perhaps. . . . It is evident that his passionate urge forward has not left him the leisure to forge for himself a personal style; his personality exists in this passion, this juvenile impetuous spontaneity.

. . . Danger lies for him in this very impetuosity which can easily lead him into a facile virtuosity. . . . This would be much to be regretted since we are in the presence of such brilliant virility."

Most important to Picasso was one of the visitors to the exhibition, Max Jacob. Jacob was a penniless poet, who earned an occasional living as a secretary, piano teacher, tutor, and art critic. This man, six years older than Picasso, recognized the latter's genius and left an enthusiastic note for the painter. In turn Manach invited the poet to come to his studio and meet Picasso.

Jacob arrived in his top hat and elegant clothing—he always wore these to conceal his poverty—and shook hands with the painter he so admired. Since he spoke no Spanish and Picasso's French was poor, there were no words to exchange, so they shook hands again. From the looks in their eyes, their expressions, it was clear the two men would become friends. That evening Picasso's Spanish friends arrived, as usual, and Jacob was asked to join them for dinner. According to Picasso, they ate beans and, unable to make conversation, sang until the early hours of the morning.

The following evening Jacob invited Picasso and his friends to his room; they were to be accompanied by Manach, who could act as interpreter. The Spaniards immediately felt at home in Jacob's small and run-down quarters. Although there was an interpreter at hand, conversation was again carried on largely by smiles and signs.

Picasso was intrigued with his new friend and, though he couldn't understand it, asked him to read his poetry aloud. This Jacob did until dawn.

A warm and lasting friendship grew between these two men, though their backgrounds were so different; Jacob, son of a Jewish tailor-antique dealer from Brittany, would seemingly have nothing in common with the intensely Mediterranean painter. But they shared a sense of life, a wit, and a common feeling for beauty. As Picasso's French improved, they found they became closer and closer, and it was Max Jacob who later introduced Picasso to Parisian intellectual life.

At that time, however, Picasso spent most of his time with his Spanish friends: wandering through the city, going to all the museums, not only art museums, but also the city's superb museums of archaeology and history, taking from Paris all it had to offer. The one thing the Spaniards missed was a place of their own, a café which would become a communal living room where they could sit and talk. This they found in Montmartre, in the musty back room of a café called the Zut, owned by a sympathetic Frenchman named Fred. The room was filthy; the lights could hardly shine through the thick cobwebs. But there the young adventurous Spaniards gathered and drank and exchanged ideas. One day Fred surprised the habitués and cleaned off the cobwebs and whitewashed the walls. In their turn, Picasso and his friends contributed huge murals, covering the newly cleaned walls with their paintings. The back room of the Zut was theirs.

It was, however, a hard and cold winter. There was no money to buy coal, and Picasso slept using books for a pillow and piling all his clothing on top of him in place of blankets. His paintings changed radically, too. All the vivid color disappeared, to be replaced by a cold blue. Instead of reflecting the gaiety of life, these pictures were sad—portraits of society's outcasts, the suffering and the lonely. Manach was angry; his protégé's latest paintings were far more difficult to sell than the lively joyful ones. The public wanted happiness, not gloom. Tension developed between him and Picasso; their relationship would have to come to an end. Picasso too seemed suddenly weary, and he wrote to his father for money to return to Spain. He was still restless. When the money arrived, he departed for Barcelona. This second visit to Paris had been an important one: he had learned the meaning of suffering, he had developed compassion for the desperate and lost people of the world. It had been the beginning of what is now known as his blue period, where sadness as well as a prevailing blue color had entered his paintings.

Restlessness, too, marks the period in Barcelona which began in December 1901. There was a happy reconciliation with his parents, and Picasso again lived at home, but he quickly found a studio which he shared with another painter. He returned to Els 4 Gats, and he spent much time at a new artists' meeting place, the Guayaba, but he earned little money and spent many hours wandering through the city. There he found the same poverty and suffering that he had found in Paris and, as he had begun to

do in Paris, he painted it. Thin, worn figures, with bowed heads—reminiscent of El Greco, whose works Picasso admired—the sad and the homeless, so it was that the blue period developed, and with it his ability to depict sadness with one continuous telling line.

The news from Paris was not good. In April 1902, Berthe Weill gave an exhibition of thirty of his oils and pastels. There were no sales. The same was true of a second exhibition at Vollard's. Critics were taking notice, and his unusual technical skills were highly praised, but his work, most likely because of its somber themes, was not being bought.

Nonetheless, Picasso's mind was on Paris. It was becoming clear that although he worked, the intellectual and artistic climate of Barcelona was not sufficiently stimulating for him. That his work was not understood is made clear in a letter he wrote to Max Jacob at the time. In this letter, illustrated with bullfight scenes and a self-portrait—drawing was always his true language—he wrote: "I haven't written to you for a long time. It's not that I've forgotten you, but I am working very hard. . . . I show my work to my friends, the artists here, but they find it has too much soul and not enough form. . . ."

In the fall of 1902, Picasso was back in Paris. He was happy to find his friend Jacob again; the latter was earning a meager living as a part-time tutor to a small boy. The top hat and the elegant long clothes (Picasso too wore a top hat and paid great attention to his clothing) served to hide an even greater poverty. But shortly after Picasso arrived,

58

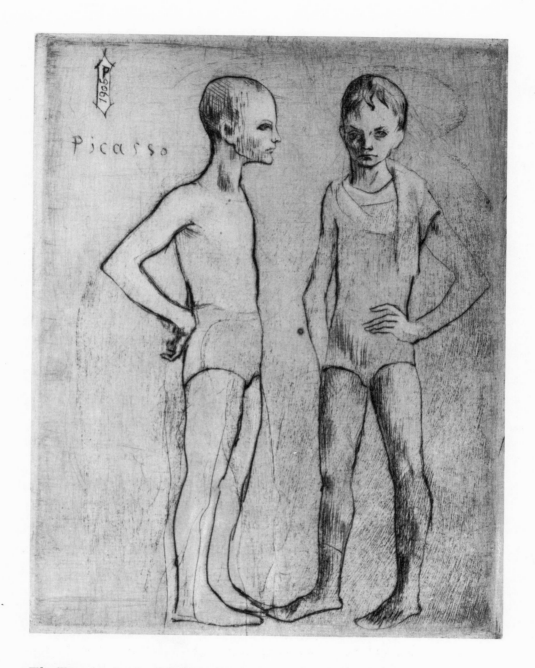

The Two Mountebanks, 1905. (Drypoint.) Courtesy of The Art
Institute of Chicago

Jacob's family came to the rescue; his uncle, who owned a department store, gave the young man a job there. With this money, Jacob was able to rent a room which he immediately offered to share with the Spanish painter. The salary could not have been high, however, for there was just one bed. So Picasso worked all night and went to sleep only when Jacob vacated the bed in the morning in order to go to work.

In a very short time, Jacob lost his job; he was obviously not cut out to work in a department store. The two friends lived in total poverty. Everything seemed to go wrong; even the sausages they bought with a few pennies were so old that they popped when put in hot water, revealing nothing but empty skin. They moved to a new room, but didn't even have enough money to buy candles to enable Picasso to work at night. Picasso was selling nothing; he even burned his watercolors to provide a small amount of heat at night.

It was clear that he would have to return to Barcelona, and he put all his efforts into selling something so that he might pay the fare. It wasn't easy. Finally, as he was beginning to give up all hope, he sold a pastel; the earnings just covered his fare home.

The year Picasso then spent in Barcelona was probably the most fruitful one of his life up to that time. He returned to the studio he had shared with Casagemas, sharing it this time with another painter, and there his blue period reached its height. Some of those paintings which

are best known today were painted there, and from some of the titles we can understand Picasso's mood at the time: *The One-Eyed Woman, The Old Jew, The Blind Man's Meal, The Old Guitarist.* The theme of blindness recurred, along with the suffering of beggars, the poor, and the sick. The work of this period is almost always blue, the icy blue of sadness and despair. These paintings are, in a way, too pathetic and sentimental, but Picasso at the time was brooding deeply over the meaning of human despair.

Picasso continued to work with increasing energy. Early in 1904, he was able to move into a studio of his own. Working alone was always important, as important as was the company of his friends outside of work. He was particularly pleased that he had his own key, for he had not had a studio of his own since his father had given him one during his adolescence.

As productive as he was in Barcelona, his mind was still on Paris. His work was getting to be known there, and he was being talked about. Paris opened new horizons to him, while Barcelona was too confining. He needed the artistic currents that flowed through the French capital, and at the end of April he left for Paris. This time it was not to be merely a visit. He would make Paris his home.

4

PARIS
AND A NEW CENTURY

When Picasso came to settle in Paris, he entered into a
dynamic, exciting world. It was a new century and pre-
sented a challenge as such. All had started in 1900 with
the great Universal Exposition, which drew thirty-nine
million visitors to the French capital, visitors who were
able to glimpse the past and get a look into the future. The
decade ahead brought years of steady change. In 1900
there were three thousand automobiles in France; by 1907,
there were ten times that many. Electricity, too, became

common in those years, and it was in 1903 that the Wright Brothers began one of man's greatest adventures: they flew their twelve-horse-powered plane a distance of forty yards in twelve seconds. By the end of 1905, they were able to fly twenty-four miles.

Real changes were taking place in the world of art as well. The face of Paris had recently been transformed by the development of color lithography, printing from stone in several colors, enabling some of the great artists of the time—especially Toulouse-Lautrec—to execute colorful, bright posters which enlivened the city streets. For a new theater, serious painters were asked to design sets and costumes—painters like Bonnard, Vuillard, and Maurice Denis.

The first years of the century saw important exhibitions of the works of Seurat, Van Gogh, and Toulouse-Lautrec. But these painters, masters in their time, were dying. By 1900, Van Gogh, Seurat, and the important Impressionist painter Sisley were dead. In 1901, Toulouse-Lautrec died; in 1903, the Impressionist Pissarro and Gauguin, the latter in his place of final exile, the Marquesas Islands. Degas was going blind, and Monet and Renoir, though they still had important work ahead of them, were sick men.

It was the end of one era and the beginning of a new one. In those first years of the century, artists with new theories and new ideas came to Paris—either to live there or to visit. From other parts of France came Georges Braque and Fernand Léger. Jean Arp and Marcel Du-

champ arrived, as did perhaps the greatest sculptor of this century, the Rumanian Brancusi. Wassily Kandinski, the pioneer of abstract art, and Paul Klee visited the French capital, and the Russian Chagall and the Italian Modigliani came to settle there.

Many of these men would take part in the revolution that was to become modern art. But the major force, the greatest genius among them was to be Pablo Picasso.

Upon his arrival in the French capital, Picasso moved into what is now a legendary building, the Bateau-Lavoir (Washing Boat). Resting, it seems, precariously on the slope of a hill in Montmartre, off what looks like a small village square, this crumbling, dilapidated wooden building had long been a home for artists and writers. It had been known for years as the Maison du Trappeur, the House of the Trapper, and its rather inappropriate new name was given it by Max Jacob. About the only thing boatlike about the Bateau-Lavoir was the fact that the main entrance, off the square, was on the top floor.

When Picasso moved in, he found himself surrounded by members of the Spanish community, other painters and sculptors as well as poets, actors, a dressmaker, and a washerwoman. Their quarters were unmistakably poor—the rooms were freezing in winter and boiling in summer. However, Picasso had experienced poverty before and he set to work as usual, working late at night, and surrounded by an ever-increasing number of bohemian friends the rest of the time. His painting continued in the style of the

64

blue period and met with little success. Max Jacob, whose friendship he eagerly renewed upon his return to Paris, did his best to sell Picasso's work. But Vollard was disappointed in these gloomy works. "Your friend has gone mad," he told Jacob; and Berthe Weill too was discouraged. In desperation Picasso was able to sell occasional works to a junk dealer, named Pere Soulier, who paid miserably but was at least able to save the painter from starvation. In the same way he sold paintings to an ex-circus clown, Clovis Sagot, who was also willing to hang a few paintings in his bric-a-brac junkshop. Paris was indeed the center of the art world at this period, but there were no more than a half dozen art galleries in the city at the time. Fortunately, furniture and junk dealers were often willing to hang works of art in their shops, thereby exposing them to the public who saw little art outside of museums and official exhibitions. The publicity machine that has taken over so much of the art world today had not yet been born; collectors of modern, contemporary painting were very few, and the public was poorly informed.

Shortly after moving into the Bateau-Lavoir, Picasso met one of his neighbors, a beautiful young woman named Fernande Olivier. Fernande was to brighten his life considerably, and they lived together for seven years. In her touching memoirs, *Picasso and His Friends*, she describes their first meeting and her first impression of the painter's studio: "There was a mattress on four legs in one corner. A little iron stove, covered in rust with a yellow earthen-

ware bowl on it, served for washing; a towel and a minute stub of soap lay on a whitewood table beside it. In another corner a pathetic little black-painted trunk made a pretty uncomfortable seat. A cane chair, easels, canvases of every size and tubes of paint were scattered all over the floor with brushes, oil containers, and a bowl for etching fluid. There were no curtains. In the drawer of the table was a pet white mouse which Picasso tenderly cared for and showed to everybody."

Montmartre was still very much like a small village in those days, and in spite of their hardships—Fernande couldn't leave the studio for two months because she had no shoes—there were always ways of enjoying life. More and more, Picasso's studio became the center of a large and stimulating circle of young artists and writers. Everything was a challenge for ingenuity. Restaurants had to be found where the owners were willing to serve meals on credit. Another system, when hungry friends filled the studio, was to order food to be delivered and then not answer the door when the delivery was made. The food was thus left in front of the door, and the impossible task of paying for it was put off till at least the next day.

In the afternoons and evenings, Picasso and his friends would gather together and talk endlessly—about everything from paintings to sports. Unable to afford tickets for the theater, they acted out their own plays. Sometimes on Fridays they could get together enough money to go to the circus. This was a great treat for Picasso. And then Fred, their old friend, opened a large café, Le Lapin

Agile, where the Picasso Group, as they were called, gathered together for hours—on the terrace in the summer, and in the dark smoke-filled main room in winter.

The love of Fernande plus his wide circle of interesting new friends changed Picasso's mood. More and more poets, along with artists, began to surround the Spanish painter, and most important of these was Guillaume Apollinaire. Half Polish and half Italian, Apollinaire understood Picasso's aims as the Spaniard understood his. Both of these men in some way wanted to change and broaden the range of their arts, and Apollinaire, a brilliant original poet, became an influential, sensitive art critic. The stimulating friendship of this remarkable man was of great importance to Picasso until Apollinaire's death in 1918.

Picasso, too, in spite of his unwillingness to fight for exhibitions, began to become known as a young painter of great promise. A few discerning collectors began to buy his work, among them a German named Wilhelm Uhde and a Russian named Shchukine, who built up impressive collections. Probably the most important, and earliest, collector was the American Gertrude Stein.

Gertrude Stein, born in Pittsburgh in 1874, was in every way an extraordinary woman. She was a short, sturdily built woman with strong, chiseled features, unusually dressed in a heavy brown corduroy suit. At the time of her death in 1946, she was known as one of the major figures in twentieth-century American letters, her style being a major influence in the writings of Ernest Hemingway, Sherwood Anderson, F. Scott Fitzgerald,

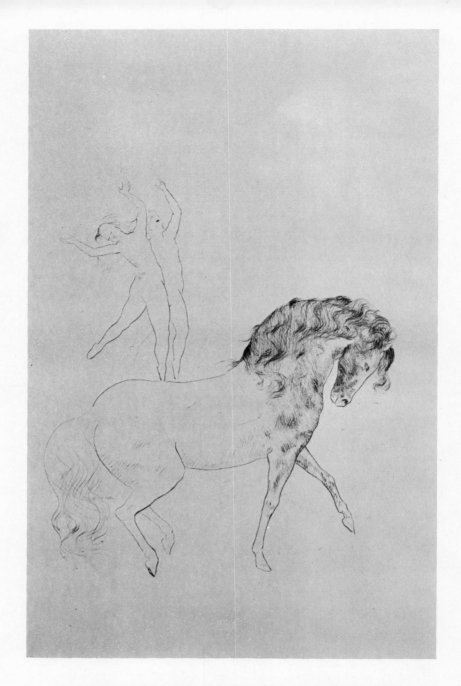

At the Circus, 1905. (Drypoint on copper.) Collection of The
Museum of Modern Art, New York

and many others. Because of her renown as an "influence," her standing as a brilliant, sensitive, and witty writer is often overlooked. After studying psychology under William James at Radcliffe College, Gertrude Stein received an M.D. degree from Johns Hopkins in Baltimore. But she never practiced medicine and in 1902, with her brother, Leo, she went to live in Paris. Once there, the two Steins soon became the center of the city's avant-garde literary and artistic life. It was Leo Stein who first saw a Picasso painting of a nude girl with red flowers in Clovis Sagot's shop. In spite of his sister's objections—she didn't like the girl's legs—Stein bought the painting. Nonetheless, Gertrude Stein was impressed by the artist, though she didn't care for this one painting, and soon afterwards a meeting was arranged. Picasso was immediately impressed by this American poet and her imposing presence. Gertrude Stein and the Spanish painter became the closest of friends. The Steins bought several canvases from Picasso, and the latter became a regular guest in their home. There they would discuss life and art, there Picasso saw the magnificent paintings of Cézanne which the Steins had collected, and there he would read the popular American comic strip *The Katzenjammer Kids*, which delighted him.

His new friends and his growing success soon influenced Picasso's art; and now he had enough money to go to his beloved Circus Medrano three or four times a week. He was fascinated not so much by the performances but by the performers. Soon these performers became the

subject for his paintings, and with these works and his newfound happiness, his gloomy blue paintings turned into paintings of predominantly rosy pink color. This period in Picasso's art is generally referred to as the rose period, and the subject matter, above all, is the people of the circus—the clowns, harlequins, acrobats, and horseback riders. These paintings, far lighter in tone and spirit than his earlier work, are immensely touching. They emphasize the performers as human beings, not on stage performing their acts, but offstage, somehow resolving the conflict between the reality of their daily existence with the fantasy of their jobs. These are not ordinary circus paintings, but profound psychological studies of the performers that make up a circus. This entire period is summed up by a magnificent large painting done in 1905. It is called *Family of Saltimbanques*, and it brings together six wandering circus performers. They seem caught in a moment of inaction, or reflection, caught and somehow lost between the acts.

Picasso's friendship with Gertrude Stein grew steadily, and through her he met the great painter Henri Matisse, who was part of a school known as the Fauves, or wild beasts, because of their violent use of strong color. In the winter of 1905, Picasso asked Gertrude Stein if he could do her portrait. She agreed, and posed for him between eighty and ninety times. No one had posed for Picasso since he was sixteen years old, but almost every afternoon for three months the American writer, in her brown cor-

duroy suit, would come to his studio, sit in a broken arm-chair and pose while the painter would work, seated on a kitchen chair. When the sittings were just about over, Picasso painted out the head—he was not satisfied. Shortly afterwards, Miss Stein left for Italy, and Picasso, with Fernande, leaving the painting behind, went off to Spain.

The return to Spain was important for Picasso. He had become integrated into French artistic life and had already achieved considerable success there. But he remained, as he always would, a Spaniard, and he felt the need for a renewal that a trip to Spain would give him. He and Fernande arrived in Barcelona early in the summer of 1906; there he had a chance to show off the beautiful young woman to his family. From Barcelona, they took the train to the small town of Guardiola and from there, a twenty-mile journey on mule to their destination, the tiny, rustic mountain village of Gosol. This village of nine hundred inhabitants was, if anything, more rustic than Horta de Ebro. Picasso was once again in contact with the elements of nature, with rugged country people. His work shows their influence, and for subjects he used, in addition to Fernande, the landscapes, the workers, and farmers. The faces of Spain reappear in his painting and the return there caused a renewal of his passion for El Greco. But the major change in his work was manifested by his preoccupation with form and structure. The figures are sculpturelike, with heavy modelling. In addition to spending his spare time in talking to the people of the

village, he collected the many-shaped fossils from the area, gathering two suitcases full which he would take back to Paris.

It was a fruitful stay, cut short only by a typhoid epidemic which threatened the province.

When Picasso got back to Paris, he returned to the portrait of Gertrude Stein and painted in the head—while Miss Stein was still in Italy. It is a strong head that seems chiseled, forceful, and obviously influenced by the figures he saw in Spain. Upon her return to Paris, Picasso showed it to his subject; Miss Stein was enthusiastic. And to those who said that Gertrude Stein did not look like the portrait, the artist simply replied, "She will."

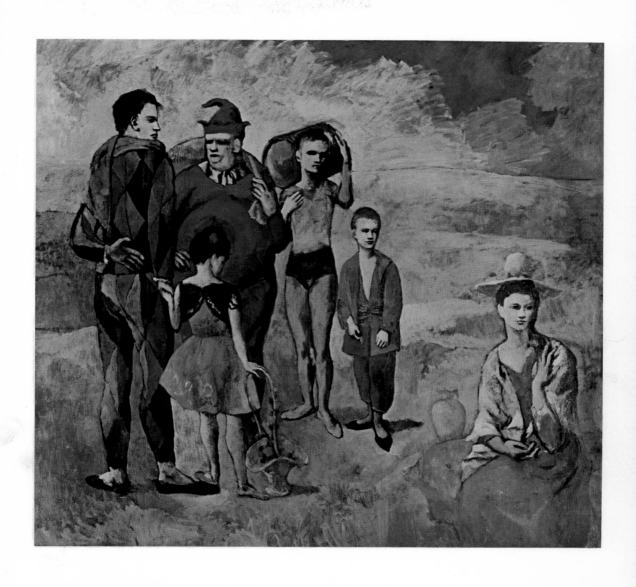

Family of Saltimbanques, 1905. (Oil on canvas.) Courtesy of
The National Gallery of Art, Washington, D.C.,
Chester Dale collection

Harlequin, 1915. (Oil on canvas.) Collection of The Museum of Modern Art, Lillie P. Bliss Bequest

74

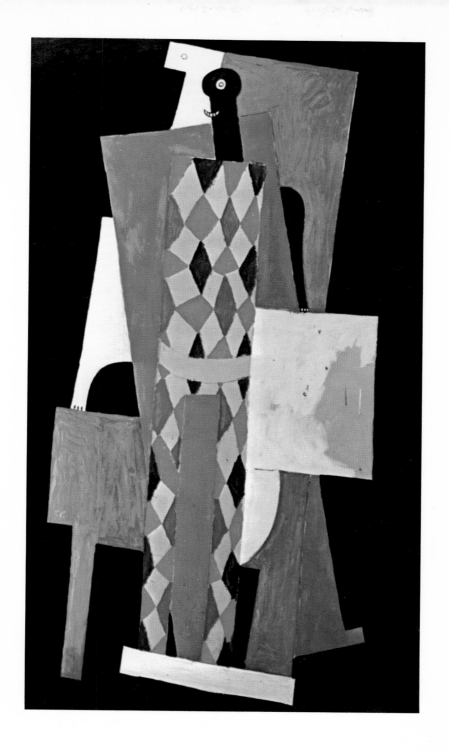

Pulcinella costume design, 1917. (Gouache.) Collection of
Mr. and Mrs. Morton G. Neumann

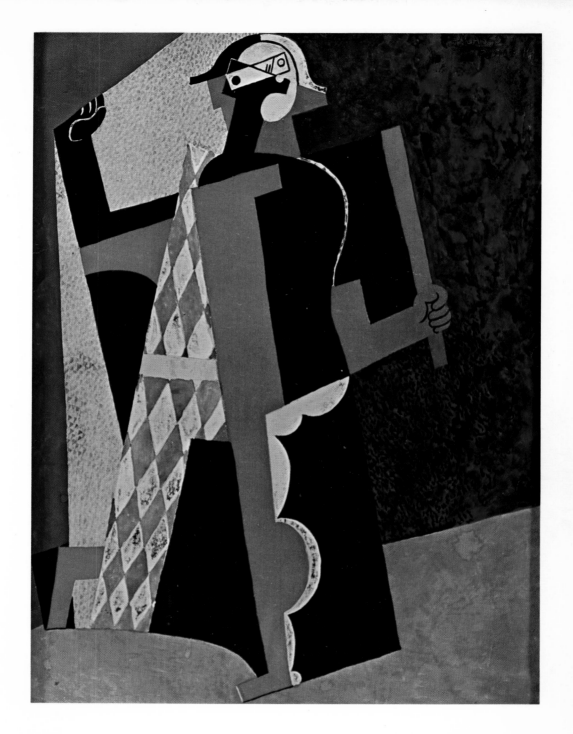

Les Demoiselles d'Avignon, 1907. (Oil on canvas.) Collection of The Museum of Modern Art, Lillie P. Bliss Bequest

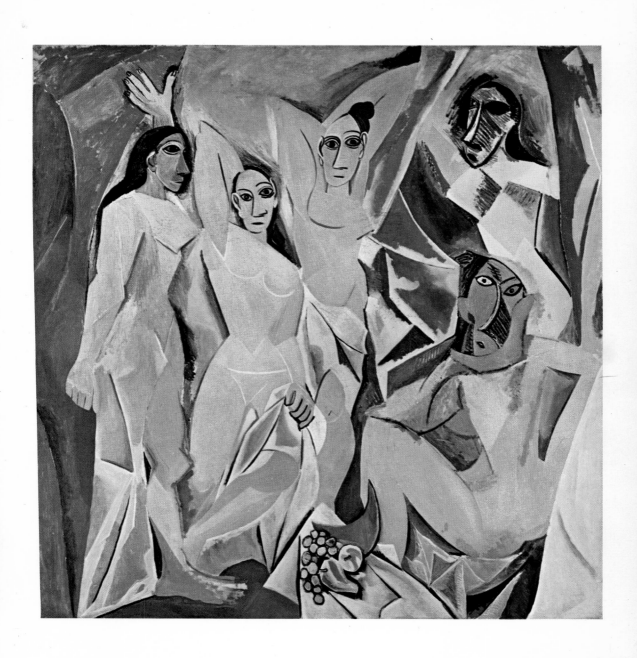

5
REVOLUTION

By the end of 1906, Picasso was reaching for something new. The paintings of his blue and rose periods had shown his mastery of one style. It was now time to move forward, to seek further. In this quest he was receptive to all influences, especially the work of the great painters that had preceded him. Of them all, at the time, most important was Paul Cézanne, the man who had first envisioned a new way of designating spatial relationships.

Most of all, however, Picasso was gaining insight and

inspiration from so-called primitive art—from Africa and Asia and from the distant past of his own Spain. For him these works, largely sculptures, which altered the proportions of the head and the body were not merely works of historical curiosity, but the results of inventive and inspired creativity.

A change came about, and the young Spanish painter —he was only twenty-five years old at the time—withdrew into himself. He was a "success" at what he had done, but that was not enough. He had to break out of the traditional mold, to explore new areas of creativity. Fernande Olivier noticed that he spent more and more time alone; his social life was curtailed. He was working without joy, without the youthful energy and excitement he had known. Instead, this was a period of self-examination, examination of the art of painting, of the values of the past and of the values and methods of the present and future. He felt a need to break new ground.

Late in 1906, he began work on what was to be the most significant painting of the twentieth-century. In solitude the artist made endless sketches and studies for this work. He prepared an enormous canvas, almost eight feet by eight feet, and made sure that it was an unusually strong one. He painted several versions—in each one figures were added and figures disappeared.

No one knew just what Picasso was doing, why his mood had changed, why he had undergone months of a curious introspection. Then, at the end of April 1907, he invited his friends to see the result of his labor. It was

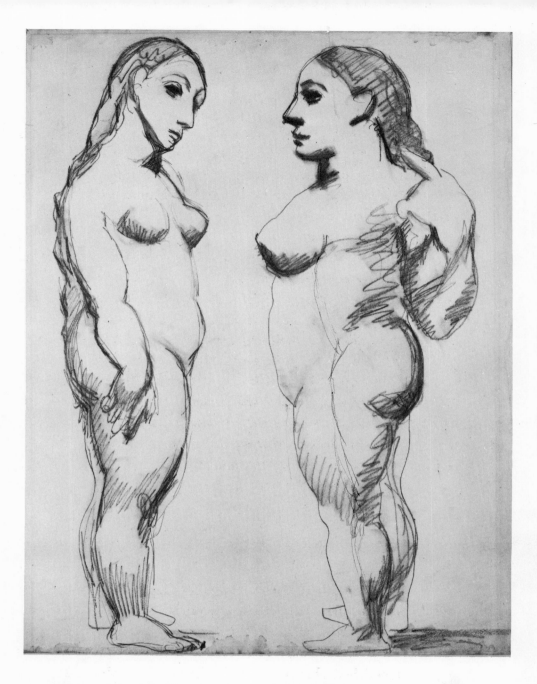

Two Nudes, late 1906-1907. (Pencil and estompe.) Courtesy of
The Art Institute of Chicago

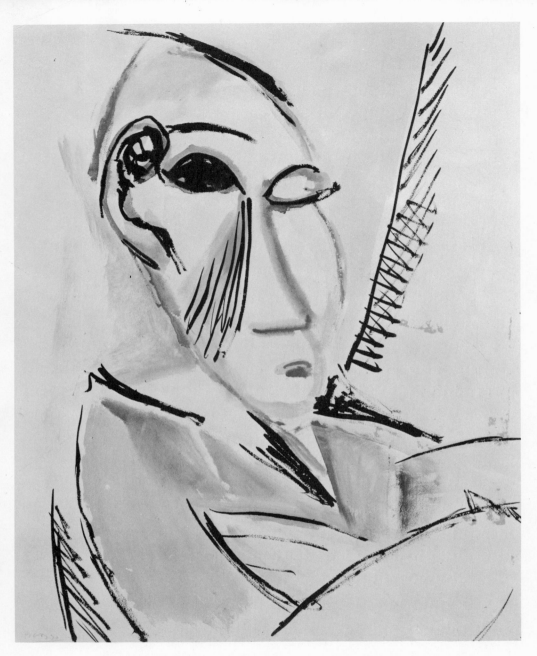

Man's Head, 1907. Study for *Les Demoiselles d'Avignon*, (Watercolor.) Collection of The Museum of Modern Art, New York

a huge painting, later named *Les Demoiselles d'Avignon,* and it was a complete shock to all who beheld it. Nothing like it had been done before.

Five nude women stare angrily, coldly, almost defiantly from the canvas; behind them draperies flutter. The three on the left are not so great a shock: the woman on the far left with a profile reminiscent of an Egyptian, and the two next to her, passive, motionless against the folds of the draperies. Their faces resemble those of the Iberian sculpture that shortly before had been shown at the Louvre. The breasts of two of these women are angular, and their noses are seen in profile and front view at the same time. They are strange, unfamiliar, frightening, and defiant figures.

Yet they are mild and conventional compared to the two women on the right-hand side of the painting. On the upper right, a nude woman with a grotesque face is seen drawing a curtain; she could be wearing the mask of a dog or a monkey. Below her sits the most astounding figure of them all, a woman with a horribly distorted face, eyes—one blue and one white—darting out in different directions, a twisted, comblike nose running down the length of her face, a tiny, holelike mouth. The body of this woman is so contorted that she can be seen from all sides, back and front.

When Picasso began showing this painting to his friends, their reactions for the most part could be summed up in one word: shock. The work was, as Apollinaire recognized, "a revolution." Georges Braque, who was to

work closely with Picasso in the following years, said that it was as if the artist drank gasoline to spit out a fire. Another important French painter, André Derain, said that it was such a desperate undertaking that one day the artist would be found hanging behind his painting. Matisse was horrified, and Leo Stein found it impossible to hide his laughter and derision. The critic Félix Fénéon suggested that Picasso should in the future devote his time to doing caricatures. A remark which has been attributed to Shchukine could sum up the feeling of most of those who had previously supported and admired Picasso: "What a loss for French art!"

There were a few exceptions, however, chief among them a young man named Daniel-Henry Kahnweiler. This twenty-three-year-old, born in Germany, had just given up the pursuit of a career as a banker in London. In 1907, he opened a small gallery which was to be devoted to exhibiting and selling the works of his own generation. Taken to see Picasso's shocking work by Wilhelm Uhde, Kahnweiler was profoundly impressed by the genius of the young Spaniard. It was the beginning of a relationship that was to last during the lifetime of both men, for since that time Kahnweiler has been Picasso's dealer.

It is impossible to overestimate the importance of *Les Demoiselles d'Avignon,* and countless pages have been written about its significance and those works which influenced it. The composition and many of the ideas the artist was trying to work out were clearly under the influence of Cézanne; the figures and their faces show the

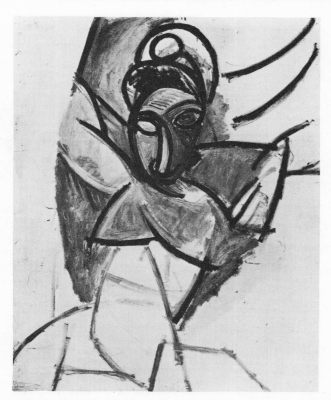

Femme, 1907. Study for *Les Demoiselles d'Avignon.* (Oil on canvas.) Private collection

influence of Gauguin, El Greco, as well as African and Iberian sculpture. However, the capital importance of the painting is found in its daring to break away from the past. No longer is the artist concerned with a "likeness"; it is not a copy or faithful representation of anything we will ever see. Picasso has used a new way of indicating three-dimensional relationships. He has distorted the human figure, has changed its anatomical proportions. By doing so, through the uses of geometrical forms, he opened up new ways to express human emotions. His use of color in this painting, too, is highly original. He is not content

to express volume by the traditional use of chiaroscuro—gradations of light; instead, the face and breast of the figure on the upper right is modelled by blue lines and the nose of the squatting figure by alternating lines of green and red.

Seen only by Picasso's friends and visitors, this key painting remained in his studio for thirteen years, unknown to the general public. Kahnweiler had bought the studies and sketches, but the artist wanted to keep the finished painting—which he has maintained was never finished. In 1920, it was sold to a French couturier, and in 1925 it was first reproduced in a publication. It was not publicly exhibited until 1937 in Paris, and in 1939 it was acquired by The Museum of Modern Art in New York, where it hangs today.

With this single work, Picasso changed the course of art history. There was no longer any doubt who Picasso was. At twenty-six years of age, he had already matured into the greatest and most daring painter of his time. There is no longer a dividing line between Picasso the man and Picasso the artist, and no need to continue to recount the facts of his life. These facts are overwhelmed by the exciting development of his art.

PART TWO
PICASSO THE ARTIST

6
CUBISM

The startling painting *Les Demoiselles d'Avignon* was only a first step towards a complete revolution in the world of art; it heralded the beginning of cubism. Up to the time of cubism, painters put on canvas what they saw with their own eyes. This was either a close facsimile of the object's reality or the artist's personal interpretation of such reality, but in both cases the resultant painting was an easily recognizable representation of the subject matter.

In cubism, the artist breaks up the elements of his

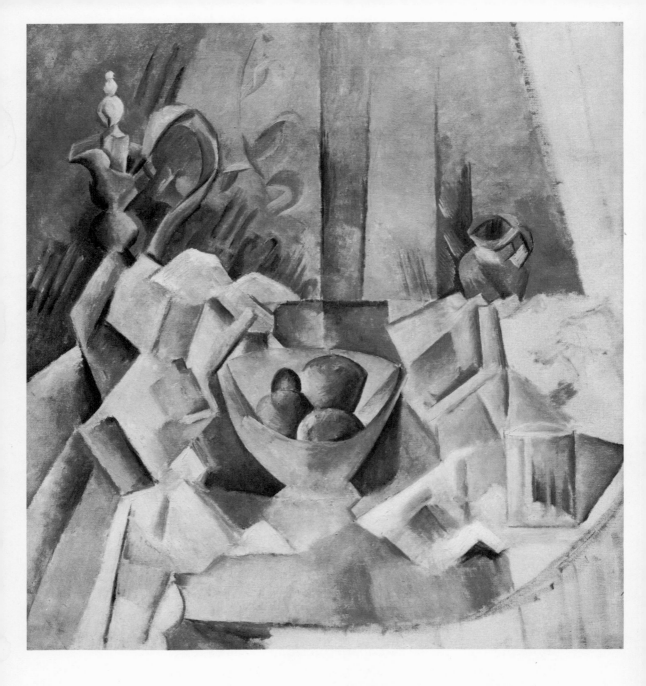

Still Life, 1908. (Oil on canvas.) Courtesy of The Solomon R. Guggenheim Museum, New York

subject and dissects or analyzes them. He expresses not only what he sees, but what he thinks is present, and envisages in his subject the invisible as well as the visible. Thus the essence of the subject is revealed on the canvas and not merely the appearance. Cubism, in the words of Kahnweiler, by its systematic study of objects, established a new grammar of painting.

This new grammar has had a lasting effect on twentieth-century man, reaching far beyond the art of painting, touching our everyday lives through modern architecture, design, advertising, and the decorative arts. A large part of what surrounds us has been influenced by cubism, and for this reason the birth and early development of this revolution in man's vision, his way of seeing, is worthy of close study.

Though the history of cubism can be said to have started with Picasso's tradition-shattering painting of 1907, its origins were in the paintings of Paul Cézanne, who wrote, "You must see in nature the cylinder, the sphere, the cone," and whose landscapes painted in the south of France clearly echo this statement. There had been a large retrospective exhibition of Cézanne's works in Paris in 1907, a year after the painter's death. Picasso was deeply impressed, and years later he said that Cézanne, whose paintings he had spent many years studying, was his one and only master. Also struck by Cézanne's paintings was Georges Braque, a brilliant painter from Le Havre, whom Picasso had met that same year through Apollinaire. Braque—a sturdy, rugged man; logical, reasonable, and

persistent—was to join forces with the daring and impulsive Spaniard in the first years of the cubist adventure. They made a strange combination—roped together in this adventure like mountain climbers, as Braque said—but the importance of cubism would not have been realized without Picasso's courage and Braque's tenacity.

They began independently, in the summer of 1908—Braque at L'Estaque in the south of France, painting landscapes inspired by Cézanne, and Picasso in Rue-des-Bois, a small village near Paris. In the fall, when they both returned to the capital, they found they had been painting in the same manner, developing what Cézanne had said and done. The results were landscapes and figures reduced to their essential construction, somewhat distorted to emphasize volume yet completely recognizable. These paintings had a sculptural quality, and their colors were limited to brown, ochre, gray, and a dull green.

Picasso would have nothing to do with official art exhibitions, those salons which were periodically held in Paris, but Braque submitted his new paintings to the Salon of 1908. Five of these paintings were rejected; Henri Matisse spoke somewhat contemptuously of "little cubes." This was the first use of the word in connection with these paintings. Later in the year, when Braque exhibited these paintings at Kahnweiler's gallery, the critic Louis Vauxcelles used the term for the first time in print: "Monsieur Braque is a very daring young man. . . . He despises form, reduces everything, places, figures and houses, to geometrical schemes, to cubes." At first used disparagingly in this

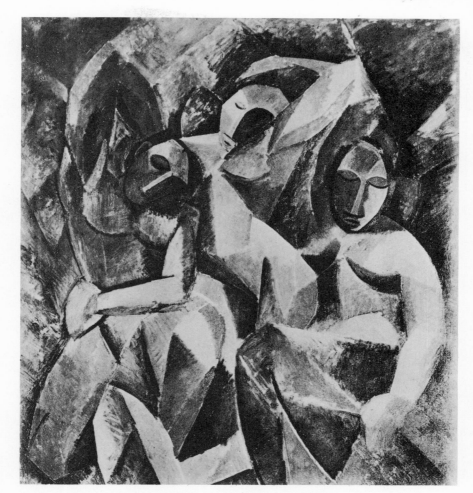

Three Women, 1908. (Oil on canvas.) Courtesy of the
Pushkin Museum, Moscow

way, the term cubism was officially adopted by Apollinaire
in 1911 to describe the new art; Apollinaire was to be its
most loyal and understanding supporter.

In 1909, Picasso returned to Horta de Ebro, where he
found his friend Pallarés again, and where the rocky land-
scapes proved ideal subjects for his increasingly geomet-
rical paintings. Forms were more profoundly analyzed,

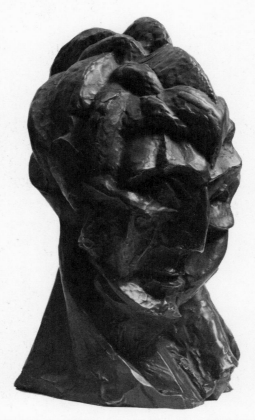

Woman's Head, 1909. (Bronze.) Collection of The Museum of Modern Art, New York

and the use of color, which would be disturbing to this minute study of form and volume, was further reduced.

The progression of Picasso's cubism during these first two years—a period often referred to as Cézannean—can be followed by examining three paintings. In the first, *Three Women* (1908), cylinders, cones, and spheres give the sculpturelike figures a feeling of movement. The

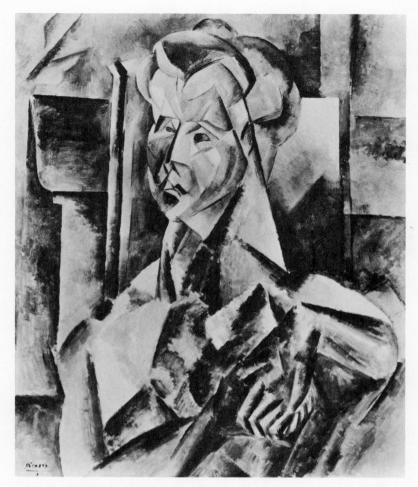

Seated Woman, 1909. (Oil on canvas.) Courtesy of
Stedelijk van Abbe Museum, Eindhoven

second, *Seated Woman* (1909), is more angular, the lines
less rigid, the figure less modelled than the earlier figures.
To express emotion, the woman's face has been broken up
into sections and put back together again. An added
dimension is thereby present. In the third painting, *Nude
in a Chair*, painted at Horta de Ebro in 1909, the woman's
face and body are again fragmented and then put back

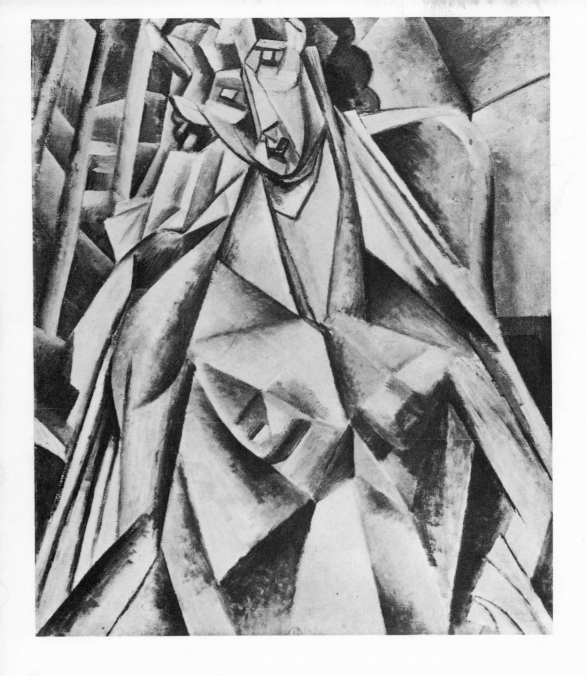

Nude in a Chair, 1905. (Oil on canvas.) Collection of
Douglas Cooper

together again; only this time the fragments are not re-placed so neatly, and the result is a somewhat distorted figure.

This process continued and advanced towards a pe-riod, from 1910 to 1912, which has been labeled analytic cubism. The transition may be traced by carefully looking at two portraits. The first is a portrait of Fanny Tellier, painted in the winter of 1910 and called *Girl with a Mandolin*. For the most part, the portrait is made up of geometrical forms—cubes, triangles, and rectangles. The head is flattened out, but a roundness, a sculpturing, re-mains in the neck, the arms, and the breast. Fanny Tellier and her mandolin are thus analyzed but remain easily recognizable.

Far different is a painting of 1911, *The Accordionist*, in that the forms have become difficult for the viewer to sort out. It is not the kind of representation to which our eyes are accustomed. The accordionist of this triangulated structure has been completely fragmented, all the forms have been broken up and the elements separated to see just what is behind them. The effect is somewhat similar to that of cut crystal. In order to give as complete a view as possible, the musician and his instrument are seen from an infinite number of angles of vision. They have been minutely dissected. At first the viewer may see nothing but a pyramidlike blur—indeed it is said that the first owner of this portrait believed it to be a landscape—but close examination reveals a seated figure, head tilted. Below the center are the keys of the accordion, and at the

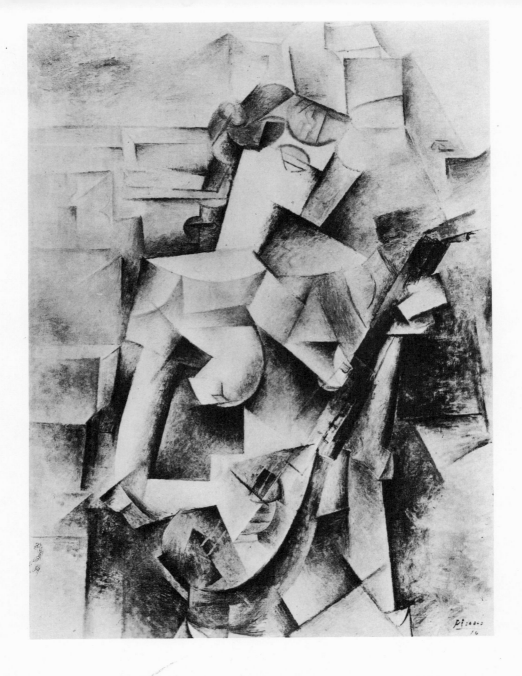

Girl with a Mandolin (Fanny Tellier), 1910. (Oil on canvas.)
Private collection

100

bottom the curved arms of the chair are recognizable.

At this period, Picasso worked closely with Braque. For a while, they didn't even sign their works, which are hardly distinguishable. Each painter eagerly showed the other what he had done and both gave and accepted criticism. Toward the end of this period of analytic cubism, with pictures like *The Accordionist*, they began to fear that the viewer might be losing touch with the reality, the subject matter of their paintings. Thus, they began to paint in very real objects—a nail, a clef signature, the handle of a violin—to provide clues that would make the works easier to decipher. Printed letters and numerals were also introduced onto the canvases. The path which would lead them to losing touch with the viewer and all reality was in this way blocked.

In the winter of 1911-1912, Picasso went one step further in a painting called *Still Life with Chair Caning*. Here a completely foreign element, an actual piece of oil-cloth made to look like chair caning, was pasted onto the canvas. This is the first example of collage (the French word for pasting), the "violation" of the canvas by the introduction of elements other than paint. Above this oil-cloth-caning are the letters JOU (the beginning of the word *journal*, French for newspaper) realistically painted in, and also seen are a glass and a sliced lemon, both cubistically analyzed. A lemon, a glass, a newspaper, and a chair —the ordinary elements of café still-life—are thus present, but they have been poetically suggested rather than stated in the accepted manner.

Guitar, Glass and Bottle (1912) is a further extension of the technique of collage and *papiers collés*. (This latter term means pasted papers.) Here everything is pasted on a pale blue background. There are cutouts from a newspaper (*Figaro*) and of patterned papers. The only actual drawing is in black on the blue background. Two of the papers pasted on have the forms of parts of a guitar. The glass is both drawn on the background and suggested by the glued-on cylindrical cutout. The bottle is represented by the word Vieux, which stands for Vieux Marc, a kind of French brandy.

The use of pasted papers and other materials added several elements to painting. By extending the number of materials an artist could use in his work, it added the possibility for a representation of complete reality. The various textures of these added materials allowed for a depth never before possible.

From the almost pure collage of this period, Picasso moved into a phase known as synthetic cubism. One example of this is *Lacerba* of 1914, but in this work, unlike the earlier collages, there is more actual painting involved. In effect, Picasso has painted in much of what he had previously pasted on. Painted on the canvas are a pipe, a guitar, a bottle of Vieux Marc, and a glass. Pasted onto the canvas, giving the whole an added dimension of space and reality, are a piece of patterned wallpaper and the front of an Italian magazine called *Lacerba*. The colors in this work are brighter than in the ones of the last years, but

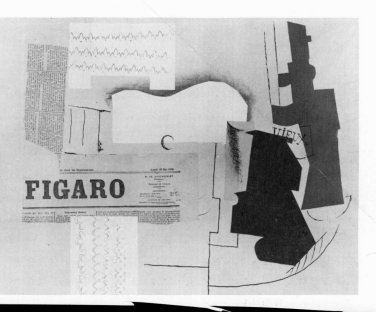

this new use of bright color is even more evident in a masterpiece of synthetic cubism, the *Harlequin* of 1915. Here all collage disappears, and the artist has created his harlequin out of large, brightly colored fragments to a joyful, gay effect. Here Picasso has employed traditional means—oil on canvas—to produce a cubist painting.

Many painters joined Picasso and Braque on the cubist adventure, notably Juan Gris and Fernand Léger, and the enormous influence of cubism is obvious in all we see around us, including the Pop Art of the 1960's. But

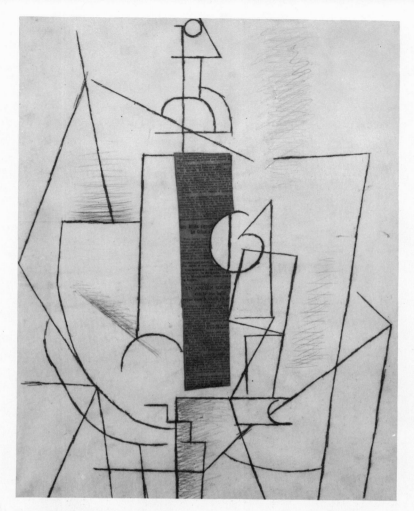

Still Life with a Bottle, 1912. (Charcoal and collage.) Collection of Mr. and Mrs. Morton G. Neumann

is said to have replied: "Very well. Let him not like it. We'll finally disgust everyone."

Everyone was not disgusted, though criticism in France must have affected Picasso, who did not show his work there publicly for ten years beginning in 1909. Nonetheless, his fame and success grew outside of France.

Throughout Europe—in England, Germany, Russia, and Italy—his work was exhibited, discussed, and admired. In the United States, his first one-man show was held in New York in 1911; he was vigorously defended by Gertrude Stein, who wrote an influential, laudatory article about the painter in *Camera World* in 1912. In 1911, too, an extraordinarily prophetic piece, written by a distinguished English writer, John Middleton Murry, was published. Murry wrote, in part:

"Picasso is one of those spirits who have progressed beyond their age. As with Plato and Leonardo, there are some paths along which pedestrian souls cannot follow, and Picasso is impelled along one of these. . . . I feel that Picasso is in some way greater than the greatest because he is trying to do something more. . . . They who condemn Picasso condemn him because they cannot understand what he has done in the past, and are content to assume that all that is beyond their feeble comprehension is utterly bad. . . ."

Cubism is the most talked-about and written-about art movement of our time, as well as the most influential. It is easy to over-complicate and over-analyze what is clearly a complex subject, but perhaps Picasso's own words are the best answer to its critics and interpreters.

"Mathematics, trigonometry, chemistry, psychoanalysis, music, and what not have been related to cubism to give it an easier interpretation. All this has been pure literature, not to say nonsense, which brought bad results, blinding people with theories. Cubism has kept itself

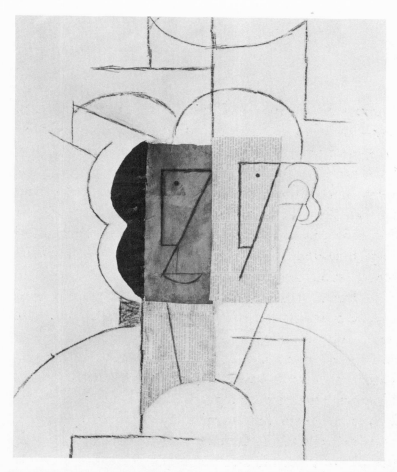

Man with a Hat, 1912. (Charcoal, ink and collage.) Collection of The Museum of Modern Art, New York

within the limits and limitations of painting, never to go beyond it. Drawing, design, and color are understood and practiced in cubism in the spirit and manner that they are understood and practiced in all other schools. Our subjects might be different, as we have introduced into painting objects and forms that were formerly ignored. We have kept our eyes open to our surroundings, and also our brains."

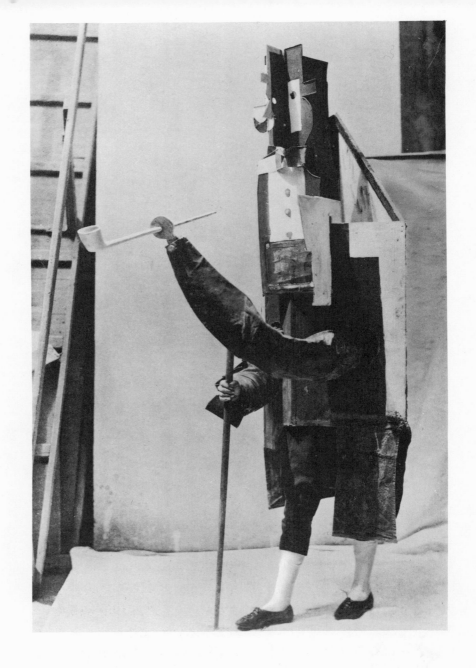

Parade, The Manager, 1917. Costume and mask

108

7
THE MAN
OF THE THEATER

Three of Picasso's key works in the decade following World War I are entitled: *The Three Musicians, The Pipes of Pan,* and *The Three Dancers.* From their titles, it is obvious that all of these paintings are concerned with music or dance. It was during this period, too, that Picasso first became directly involved with the theater.

He had, of course, always been concerned with the world of the spectacle. When he was only eighteen years old, he was painting scenes of crowded dance halls and musical cafés. Then came the period during which the circus

fascinated him, when he drew and painted clowns and acrobats with such understanding and compassion. The bullfight, too, had been one of his passions, and the bullfight to a Spaniard is far more than a sport: it is, above all, a dramatic spectacle. To this day there are countless stories of Picasso's pleasure at wearing masks, of his dressing up in absurd, comical costumes, from African headdresses to a cowboy hat presented him by Gary Cooper.

Nonetheless, it was in 1916 that Picasso first worked actively in the theater. World War I had broken out in 1914, and the intellectual and artistic life in Paris had been thrown into chaos. Many painters, including Braque, were drafted into the army. Apollinaire, to prove his loyalty to France, applied for French citizenship and went to war as a volunteer. Kahnweiler, a German citizen, fled France to avoid being placed in an internment camp. All this, of course, had a depressing effect on Picasso, who remained in Paris. But during this period he became friendly with a poet and artist, Jean Cocteau, who was only twenty-five years old at the time. Cocteau had collaborated with the Ballet Russe, a tremendously successful Russian ballet company that had been enjoying great success in Paris since its debut there in 1909. The director of the Ballet Russe, Serge Diaghilev, was determined to create a synthesis of the arts by bringing together the talents of the greatest writers, painters, musicians, and choreographers of the times.

Cocteau had already decided to work with France's most important avant-garde composer, Erik Satie, to do a

ballet on the theme of a group of travelling players. In 1916, he decided that Picasso was the man to design the sets, curtain, and costumes for the production. An admirer of the Spanish painter's work, he had written that "my dream, in music, would be to hear the music of Picasso's guitars."

It would be, he knew, a difficult task to get Picasso to go along with the project. The purists of the cubist movement would certainly not like the idea of their master painting theatrical designs. Even worse, it would mean that Picasso would have to travel—for Diaghilev was to prepare the work, to be known as *Parade*, in Rome, and it would be necessary for Cocteau to bring Picasso to the Italian capital.

Surprisingly, Picasso agreed; the idea of translating cubism into theatrical terms pleased him as did the chance to see Italy. It was time for a change, too, and in February 1917, a delighed Cocteau brought Picasso to Rome. By day, the painter worked on the enormous drop curtain and on the designs for the costumes and sets. At night, accompanied by members of the troupe, he would walk through the endlessly enchanting city. He entered enthusiastically into a world he had always been drawn to, and he formed an attachment to one of the dancers, the beautiful Olga Khoklova. In every way the collaboration among Picasso, Leonide Massine, the choreographer, Diaghilev, and Satie worked successfully.

After a month in Rome—with short side trips to Naples and Florence, where Picasso had a chance to see

masterpieces of classical and neoclassical art—the task was finished, and the company returned to Paris.

On May 18, 1917, at the Châtelet Theatre, *Parade* had its premiere. The audience, used to and enthusiastic for traditional dance, music, and decor, was wary of what to expect. They feared the results of a collaboration between Picasso, the revolutionary leader of cubism, and Satie, the most daring French composer at the time. When the overture was played and the drop curtain shown, they were reassured. Satie's music was austere and serious; Picasso's brilliant curtain, too, could hardly shock. It was largely representational, with memories of his rose period. But when the curtain was raised, it was a different story. The music was laced with sounds of engines, sirens, trains, planes, and typewriters. Then three figures appeared on the stage—the Managers, one French, one American, one, a horse. They were huge cubist figures, only their feet showing beneath the boardlike costumes. These monstrous figures dwarfed the rest of the cast—a wild, ugly little girl, a brilliantly attired Chinese magician, and two village-square acrobats. Sections of the scenery, including a newsstand, moved across the stage. The audience was furious. Boos and hisses echoed throughout the enormous theater.

At the end of the performance, there was chaos. "Picasso, Satie, and myself couldn't even get backstage," Cocteau was to say. "The crowd had recognized us and was threatening us. The women had their hatpins out and would have probably stabbed us to death . . ."

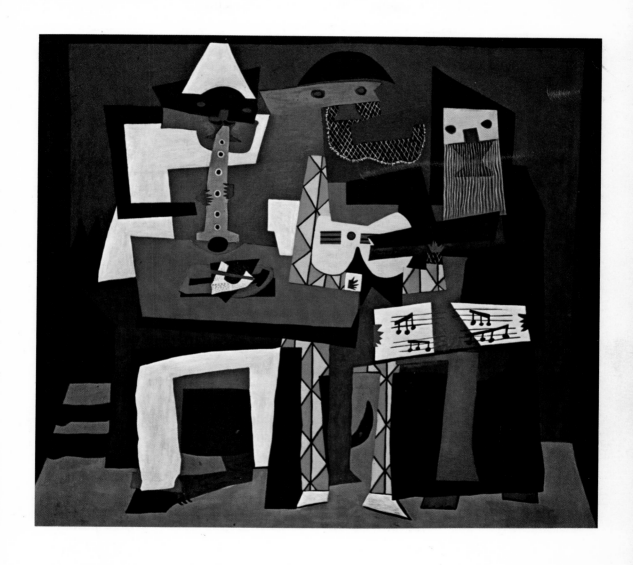

Three Musicians, 1921. (Oil on canvas.) Collection of The
Museum of Modern Art, Mrs. Simon Guggenheim Fund

Man With a Pipe, 1915. (Oil on canvas.) Courtesy of The Art
Institute of Chicago

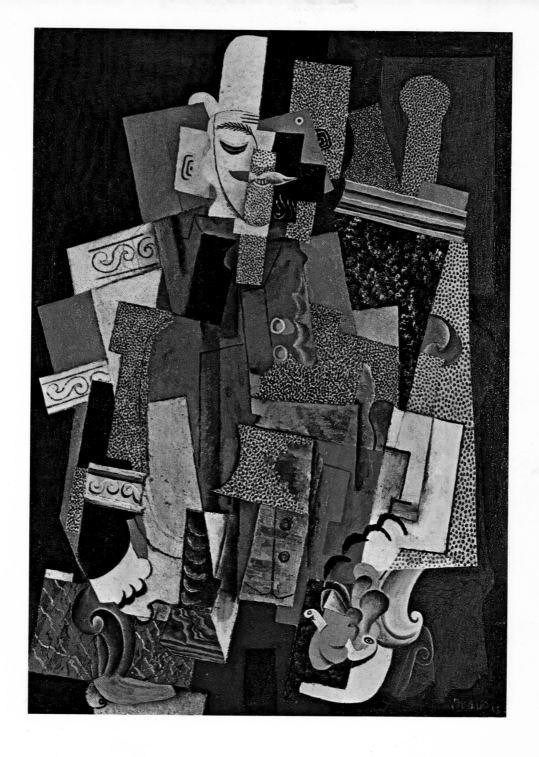

115

The Red Armchair, 1931. (Oil and enamel on plywood.)
Courtesy of The Art Institute of Chicago

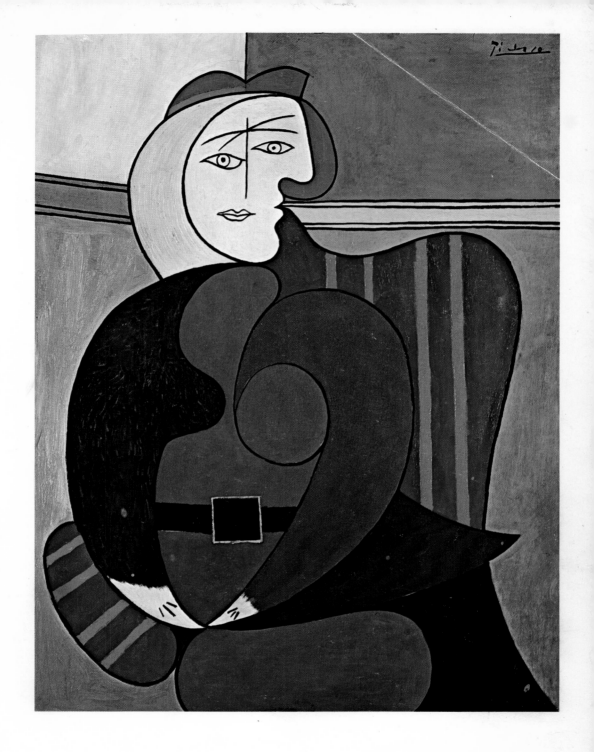

117

Seated Woman, 1941. (Oil on canvas.) Collection of Mr. and
Mrs. Morton G. Neumann

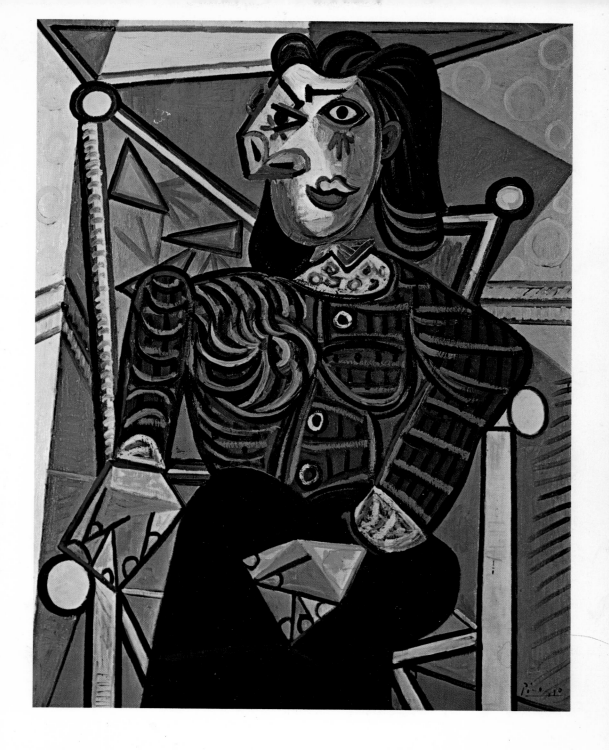

119

In spite of the audience and critical reaction—the latter was so bad that in answering a critic Satie was sent to jail for defamation of character—Picasso continued to work with the ballet. He accompanied them on a tour through Spain, an important tour for them since it was there that the Russian Ballet was to find refuge during the war. For Picasso, it was a heroic return: the Spanish painter had become an internationally famous figure. In addition, he was able to introduce his new companion, Olga, to his family.

From Spain, the company went to London, and for London Picasso collaborated on another work, *The Three-Cornered Hat*, to the music of Spain's greatest contemporary composer, Manuel de Falla. A more classical and traditional work than *Parade*, *The Three-Cornered Hat* was a triumph at its opening at London's Alhambra Theatre on July 22, 1919.

Over the next few years, Picasso was to work on other ballets, including one to the music of Igor Stravinsky, *Pulcinella*, in 1920. A new world had revealed itself to Picasso, and he found great stimulus from the people among whom he worked. He did brilliant portraits of many of them—Satie, Cocteau, Stravinsky, Diaghilev, and of Ernest Ansermet, who conducted the premieres of *Parade*, *The Three-Cornered Hat*, and *Pulcinella*.

In 1918, Picasso married Olga, and his life changed. Olga came from an upper-class, traditional family. Her first act was to convince her husband to move from his bohemian surroundings to a residential, sedate apartment

on the rue La Boetie. Olga was conventional, and this very conventionality appealed to Picasso as another challenge. Olga wanted respectability, with nurses (their child Paulo was born in 1921), maids, cooks, and chauffeurs.

For Picasso, these first years were tranquil ones, and this tranquility is clearly demonstrated in one of the three key paintings of the period.

The first is *The Three Musicians*, which can be considered the summing up of his late synthetic cubism. It is what has been called decorative cubism—severe, simple, stark, almost solemn in its perfection.

In front of a dark, stony background, are the three musicians. One is Harlequin, the comic character from the Italian *commedia dell'arte*, a traditional masked figure in multi-colored, triangulated tights—Picasso had certainly renewed his acquaintance with this figure while in Italy. Harlequin is playing the guitar, and next to him sits Pierrot, the French pantomime figure, with whitened face and elaborate white costume, who plays the clarinet. At the end sits a monk—not really a musician, but he holds the musical score on his knees. Under the table lies a dog. All these precisely cut geometric forms, carefully fitted together, give a feeling of serenity, but also one of emptiness. The whole is well ordered, well organized, and remarkably perfect in its harmonies.

The second painting, *The Pipes of Pan*, dated 1923, reaches another kind of serenity and perfection. It is a prime example of what is called Picasso's neoclassic period, and one of the artist's own favorites. Neoclassicism is a

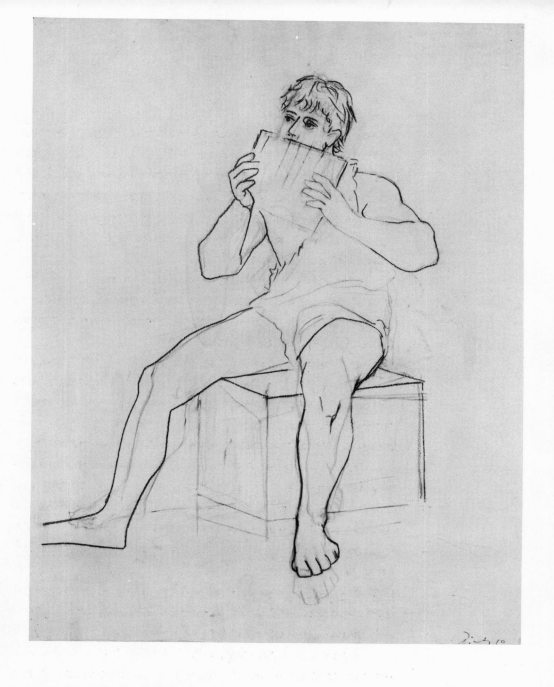

The Pipes of Pan, ca. 1923. (Charcoal, study for the painting.)
Courtesy of The Art Institute of Chicago

movement of artists who believed in carefully copying the models of antique art. The themes are classical, like those found on Greek vase paintings, and the works of neoclassicism are noted for their simplicity and perfection of form.

The Pipes of Pan is but one of Picasso's many neoclassical paintings of this period. Just as *The Three Musicians* was in a way a calm summing-up of cubism, so these neoclassical works can be considered a period of calm, of rest, of the painter taking stock of himself.

In *The Pipes of Pan*, two young men in shorts are placed against a calm opaque blue background. The one on the left stands strongly, his arms down, his right arm on his right leg. He listens peacefully while his companion on the right, seated, plays his tune on the panpipes. The two figures seem molded, as if sculpted. Nothing extra, nothing superfluous is added to the painting. It is pure, untroubled, immobile.

If these two works signify repose and calm, the next important work, *The Three Dancers* of 1925, begins a period of turbulence. In 1925, André Breton, the French poet and critic and one of the leading thinkers of the time, wrote that the distinguishing features of the modern mind were its restlessness and convulsiveness. *The Three Dancers* echoes this. At the same time, Picasso's personal life began to bore him; he could no longer stand all the middle-class conventionality with which he was surrounded and has said that at this point in his life he wanted to put a sign on his door that said: "I am not a gentle-

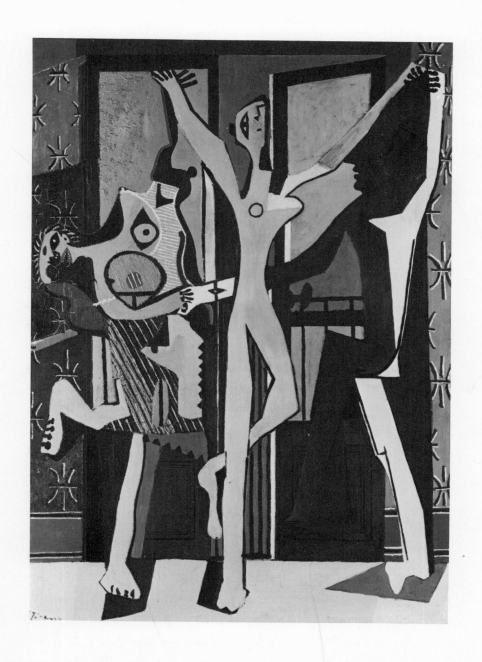

The Three Dancers, 1925. (Oil on canvas.) Courtesy of
The Tate Gallery, London

man." *The Three Dancers* is not a gentleman's picture. It is a shocking and disturbing painting, one which deserves the greatest of attention. Nothing in Picasso had shocked as much since *Les Demoiselles d'Avignon.*

The canvas is a tremendous one, over seven feet high. On it are three life-size figures, seemingly flat, silhouetted against large windows. Outside can be seen the grillwork of a balcony. Inside, the walls are covered with patterned wallpaper. The dancer in the center has her arms raised and spread out; her legs are raised as in a dance, ~~but she is the least hysterical of the three~~ dancers. The dancer on the right is a figure out of synthetic cubism, ~~composed of cutouts of~~ [colored] black, brown, and white. She holds her hands behind her back as does the dancer on the left. It is this distorted figure that is the most striking of all. Naked except for a skirt, her head and torso are thrown back, her right leg kicked behind her. Her twisted face seems a nightmare mask. She is wild and exudes animal energy. The entire effect of this ~~remarkable~~ painting is one of frantic, rhythmic movement, such as no artist has before or since captured on a canvas.

There have been many interpretations of *The Three Dancers.* Picasso himself has said that the shadow silhouetted behind the dancer on the right is the profile of his close friend, Ramon Pinchot, who had just died. This has led critics to call this work a kind of crucifixion, and biographical elements can well be read into the working, giving it broader meaning. Yet it is Picasso himself who

has always said that it is futile to interpret a work, for no viewer can really enter the skin of a painter. *The Three Dancers* can stand without interpretation, as a fascinating, horrifying, revolutionary work of art.

The Dream and Lie of Franco, 1937. (Etching.) Courtesy of The
Solomon R. Guggenheim Museum, New York

8

GUERNICA

During the 1930's, seeds of a new war in Europe were being planted, and in the middle of July 1936, a bloody civil war broke out in Spain, a war that many consider the first battle of World War II. The opposing forces were the liberal Republican government and the insurgent military, led by General Franco, a supporter and proponent of Fascism.

Picasso was in Paris at the time, and news of the Fascist uprising reached him not only through the French

newspapers but was also brought to him by Spanish visitors who passionately told him of the horrors of the Fascist uprising. Many of them were to take up arms in defense of freedom. That same month, Picasso was offered the post as director of the Prado. He accepted with pride, though the position was to be an honorary one; Picasso did not go to Spain and the paintings themselves, in danger from air attack, were transferred from the museum in Madrid, the capital, to Valencia.

There was no question that Picasso was deeply troubled by the tales of war in his native country. And there was no question of where he personally stood—in firm opposition to the threatening Fascist dictatorship of General Franco. He would use his art to serve as a weapon. He first graphically expressed his rage through a series of etchings in January 1937. The title of the series was called *The Dream and Lie of Franco*; it consisted of two plates, nine scenes each, with accompanying text in the form of a poem. Fourteen of the scenes were done in January, the remaining four several months later. They can be read like a comic strip, a form Picasso enjoyed, as was foretold in his own "comic strips" illustrating the life in Corunna in his youth, and in his later enthusiasm when Gertrude Stein showed him American comic strips. Franco throughout is depicted as a monster of cruelty, or, as Picasso says in the accompanying poem, "an ill-omened octopus . . . his mouth stuffed with the bed-bug jelly of his words . . . held over the codfish ice-cream cone fried in the scabs of his shackled heart." Picasso's drawings

reflect the bitterness of his words and vice versa. These eighteen scenes were later reproduced on postcards and sold for the benefit of the Republican Government.

In that same month of January, 1937, Picasso was asked by the Spanish government to create a mural for the huge International Exposition to be held in Paris in the summer of 1937. He was the pride of his country, and it was hoped that the work would be of such importance that it would draw attention to Spain's tragic situation. Some of the most important painters of the time were decorating the various pavilions of the Fair—Robert Delaunay for the Railway Building; Raoul Dufy for the Building of Light; and Fernand Léger for the Building of Discovery. At the same time, and for the benefit of the large number of people from all over the world who would visit Paris for the Fair, a series of important art exhibitions were being held throughout Paris.

There is no indication that Picasso made any plans for the work to be done in the Spanish Pavilion during the first three months of 1937. The idea for the work came to him with dramatic impact in late April, with the brutal and senseless bombing of the small Spanish town of Guernica by the German air force, under the orders of General Franco. This is a journalistic account by the correspondent of *The Times* of London:

"Guernica, the most ancient town of the Basques and the centre of their cultural tradition, was completely destroyed yesterday afternoon by insurgent air raiders. The bombardment of the open town far behind the lines

occupied precisely three hours and a quarter, during which a powerful fleet of aeroplanes consisting of three German types, Junkers and Heinkel bombers and Heinkel fighters, did not cease unloading on the town bombs . . . and . . . incendiary projectiles. The fighters, meanwhile, plunged low from above the centre of the town to machine-gun those of the civil population who had taken refuge in the fields. . . ."

The horror of this massacre of innocent civilians, the destruction of a town which held no military significance shocked the world. This was a new kind of warfare, not the kind fought on the battlefields. A harmless market-place had been destroyed in midafternoon. Vivid and heartbreaking newspaper accounts appeared in the European and American press. Of Guernica's seven thousand inhabitants, 1,654 had been killed and nine hundred injured. Photographs showed the maimed bodies of infants, the desperate, tragic faces of the survivors of the town. But Picasso the artist was able to create a work which was to outlive all the journalistic accounts and all the photographs. Certain things could be done with a camera, and others with a canvas and brush and paints. "Why," Picasso said many years later to his photographer friend Brassaï, "should the artist persist in treating subjects that can be established so clearly with the lens of a camera? It would be absurd. . . . So shouldn't painters profit from their newly acquired liberty, and make use of it to do other things?"

Picasso made use of this liberty of the painter to create

one of the great works of the twentieth century, his huge painting for the Spanish Pavilion which was entitled simply *Guernica*.

On May 1, only a few days after the destruction of the Spanish town, Picasso began work in a huge studio, which had once been a theatrical rehearsal hall, on the rue des Grand-Augustins, in one of the oldest sections of Paris, on the left bank near the Seine. With difficulty, an enormous canvas—11 feet, 6 inches by 25 feet, 8 inches—was stretched out on the second floor of the seventeenth-century house. On this nearly three hundred square feet of canvas, Picasso would express unforgettably his protest and indignation at the horrors not only of what happened at Guernica, but of all the useless horrors of war. This superb painting was a more than adequate answer to those critics who mistakenly felt that Picasso's credo was art for art's sake, that he was not politically or socially involved. But he also articulated his feelings of the role of the artist in society in a statement written in May 1937, and printed in the *Springfield* (Massachusetts) *Republican* two months later:

"The Spanish struggle is the fight of reaction against the people, against freedom. My whole life as an artist has been nothing more than a continuous struggle against reaction and the death of art. How could anyone think for a moment that I could be in agreement with reaction and death? . . . In the panel on which I am working and which I shall call *Guernica*, and in all my recent works of art, I clearly express my abhorrence of the military caste

Composition study for *Guernica*, May 8, 1937. (Pencil on white
paper.) On extended loan to The Museum of Modern Art,
New York, from the artist

which has sunk Spain in an ocean of pain and death."

Later, in December of 1937, *The New York Times*
published another statement of Picasso's: "It is my wish
at this time," he wrote, "to remind you that I have always
believed and still believe, that artists who live and work
with spiritual values cannot and should not remain indiffer-
ent to a conflict in which the highest values of humanity
and civilization are at stake."

But Picasso's magnificent painting speaks more clearly
than any words could. Few works of art have been so well
documented. More than forty-five studies for the enor-
mous painting survive: some are sketches of the composi-
tion, others are of small details, and several are drawings or
oil paintings of individual figures. In addition, seven
photographs were taken of the mural at its various stages,
beginning on May 11. "It would be very interesting,"

Picasso had once said, "to preserve photographically, not the successive stages of a painting but its successive changes. Possibly one might then discover the path followed by the brain in materializing a dream. But there is one very odd thing—to notice that basically a picture doesn't change, that the first 'vision' remains almost intact, in spite of appearances."

Fortunately, such a record of *Guernica* does exist. Entire books have been written on the evolution and meanings of this painting; an especially good one is Sir Anthony Blunt's *Picasso's Guernica* (Oxford University Press, 1969). But such a detailed study is not necessary to give some idea of this painting's development. A mere look at some of the sketches for the figures that remain in the final work is of considerable interest. The drawing dated May 8, 1937, the second of that day, shows a mother with a dead child, a despairing figure in many ways similar to that on the final canvas. The other figure in this pencil drawing is a horse, but its shape and position are quite different from those of the horse on the completed painting.

On May 10, one of three recorded drawings is that of a horse's leg, together with the heads of two horses. The leg is a reminder, in its anatomical perfection, of Picasso's mastery as a draftsman. In order to distort the photographic image, the anatomical image that we see, the artist must first learn each actual detail and characteristic of the object to be distorted. The heads—still not like those to appear in the final work—show the painter's ability to

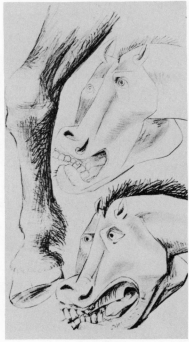

(Left) *Head of Weeping Woman*, June 3, 1937. (Pencil, color crayon and grey gouache on white paper.)
(Right) *Leg and Head of Horse*, May 10, 1937. (Pencil on white paper.) Both works on extended loan to The Museum of Modern Art, New York, by the artist

show, through the eyes, both the front and the profile views of the horse.

The work completed on June 3 shows the head of a weeping woman. It is done in pencil, color crayon, and gray gouache, and turned sideways, we can see features of the tragic head of the woman who holds the dead child in *Guernica*, particularly the mouth and tongue, and the almost teardrop-shaped eyes.

The seven photographs illustrating the changes in the painting, too, are fascinating to study. In its second state, for example, the composition, the distribution of the important figures on the canvas, has been established on both sides of the mural. But the center is considerably different from the final work: the soldier's fist, clutching the enormous flower, will disappear, and the horse, reversed, will be of far greater importance in the finished work. But the artist has already determined the composition as well as the major figures in it.

The finished work itself is a masterpiece. Much as analyses of the work and the stages leading to its completion are of interest, nothing can compare to the enormous impact of the mural itself. It is a work of art which can never be forgotten by those who are fortunate enough not only to look at it, but to see it. Its power is almost overwhelming, its condemnation of darkness and wanton destruction goes far beyond the bounds of the tragedy of one Spanish town: it is an angry outcry against all war and human suffering.

It is impossible to explain with theories or words the

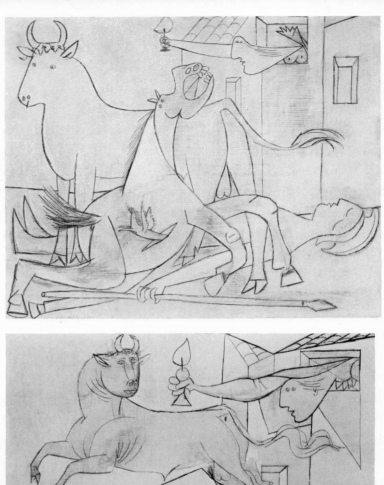

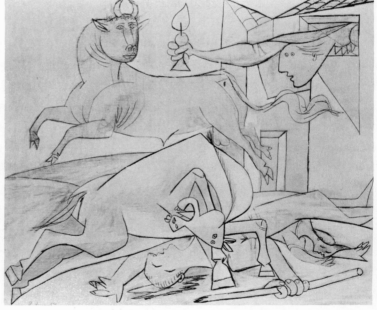

Composition studies for *Guernica*, (top) May 1. 1937, (below) May 2, 1937. (Pencil on gesso on wood.) Both works on extended loan to The Museum of Modern Art, New York, by the artist

reasons for this extraordinary effect, but the main characteristics of the work can be described. First of all, the painting is notable for its lack of color. It is all shades of gray and black—sometimes the gray has a purple tinge, sometimes a brown one, sometimes a blue one. Bright colors would not only fail to illustrate the subject: they would detract from the power of the presentation.

The viewer's attention is immediately drawn to two figures—a tormented, wounded horse near the center, and a stolid powerful bull on the left. Between them is a bird, which seems to be moaning a lament.

The human figures can be followed from right to left. On the far right is a woman, her arms stretched upward, her clothes on fire; and above her a house is burning. . . . Rushing away from this figure is another tormented woman. Above her, a woman's head, leaning out of a window, a lamp in her arm. On the ground in the center lies a wounded man—a soldier with a jagged sword in his hand. On the far left, an agonized mother, her head leaning back in horror, her dead child in her arm. And above the human and animal figures, a light bulb which seems to be in the center of an eye.

Guernica is an allegorical painting; its meaning, the ugliness of war, is conveyed by the use of symbols. Art critics and historians have given many interpretations to the different elements in the picture. The bull and the horse are open to different interpretations; it is certainly noteworthy that Picasso used in his painting these two innocent victims of the bullfight. The lamp held through

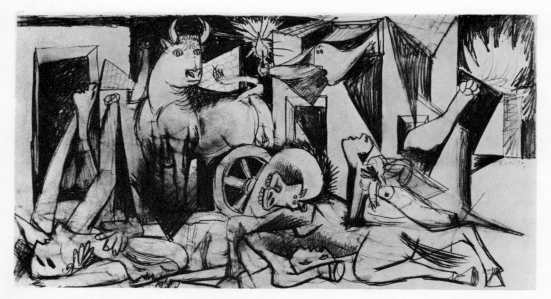

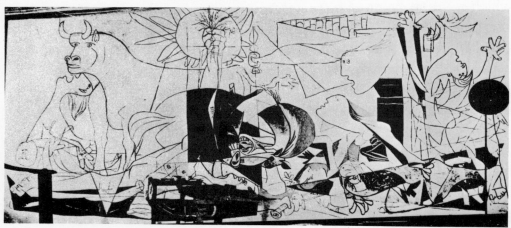

(Top) Final composition study for *Guernica*, May 9, 1937.
(Pencil on white paper.) On extended loan to The Museum of
Modern Art, New York, by the artist
(Below) Photograph of the mural in its second state. The round
black object at the right is a photographer's light.

the window could represent the light of truth; the eye and bulb above function symbolically to show us that the scene takes place at night. Commenting on the work to an American soldier, Jerome Seckler, in 1945, the artist said: "The bull is not Fascism, but it is brutality and darkness . . . the horse represents the people . . . The Guernica mural is symbolic . . . allegoric. That's the reason I used the horse, the bull and so on. The mural is for the definite expression and solution of a problem and that is why I used symbolism." But when further questioned later on the precise symbolism and its meaning, Picasso said: "The bull is a bull and the horse is a horse. These are massacred animals. That's all, as far as I'm concerned."

That, actually, is all that concerns those who look at *Guernica*. The various analyses of its symbolic meaning and the history of these symbols is most certainly of interest to specialists. However, of greater importance is the enormous impact of this powerful dramatic work of art—its angry denunciation of war and the slaughter through war of countless innocent victims.

With the Fascist victory in Spain in 1939, Picasso vowed never to return to his country—until the end of Fascism there. Since that time he has given aid to countless Spanish refugees from Fascism, and his pride in being a Spaniard remains great. But he has maintained his pledge not to return to Spain. So, too, with his masterpiece *Guernica*. It has been on loan to New York's Museum of Modern Art, and will remain there until Spain is again free from Fascism.

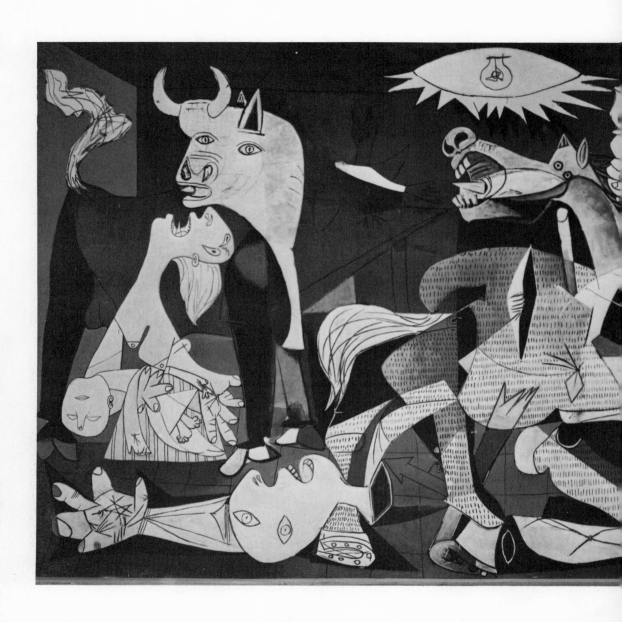

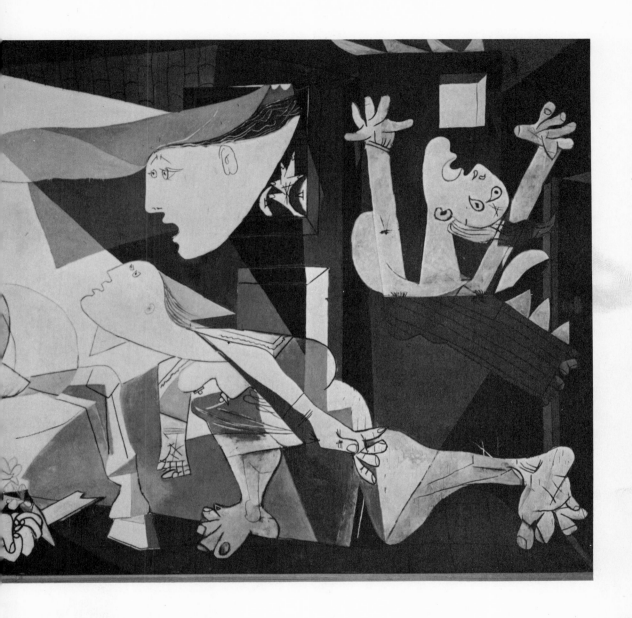

Guernica (finished mural), 1937. (Oil on canvas.) On extended loan to The Museum of Modern Art, New York, by the artist

It is unthinkable that a man with Picasso's passion and love for life and freedom could remain indifferent to political events. "What do you think an artist is?" he is quoted as saying in an article in a French magazine, *Les Lettres Françaises*, on March 24, 1945. "An imbecile who has only his eyes if he is a painter, or ears if he is a musician, or a lyre at every level of his heart if he's a poet, or even if he's a boxer, just his muscles? On the contrary, he is at the same time a political being, constantly alive to heartrending, fiery or happy events, to which he responds in every way. How would it be possible to feel no interest in other people and by virtue of an ivory indifference to detach yourself from the life which they so copiously bring you? No, painting is not done to decorate apartments. It is an instrument of war for attack and defense against the enemy."

9

PICASSO
AND OTHER PAINTERS

Hélène Parmelin, a long-time friend who has written many books about Picasso, has written that he often says that when he paints all painters, of yesterday and of today, are with him, behind him, watching him, in his studio. Picasso's enthusiasm for works of other painters, past and present, shows in his magnificent personal collection. In his home are paintings by Renoir, the Douanier Rousseau, Matisse, Cézanne, Corot, Courbet, Degas, Braque, Modigliani, and Derain. These are works that he treasures, that

he has collected over the years with taste and discrimination. In addition, his homes have always been filled with objects of every kind, bits of paper and stone and metal, objects most people would throw away but whose forms and dimensions give stimulus to Picasso. As well as this disarray of "useless" objects, Picasso has a fine collection of prehistoric, Etruscan, African, and Eskimo sculpture.

Picasso has an extraordinary awareness of the past, a knowledge of what has been painted. As with all artists, there have been specific influences on his own work. We have already seen how such varied artists as Velázquez, Goya, and El Greco among the Spaniards, as well as Impressionists and Post-Impressionists such as Manet, Degas, Cézanne, and Toulouse-Lautrec have affected Picasso's work at different times in his life. The work of others is bound to influence every artist; the sensibility of each artist merely selects those influences closest to him, those that most stimulate him. This stimulus can manifest itself in many ways—technique, style, form, or subject matter.

However, some of Picasso's most brilliant work in the 1950's came as a result of his interpretations of the works of Eugene Delacroix, Diego Velázquez, and Edouard Manet. These interpretations are not a mere matter of influence; in each of them Picasso has taken a masterpiece of another painter, studied it painstakingly, dissected its mysteries from every aspect and come up with a totally original work, one that has been inspired by other works rather than influenced by them.

In 1917, Picasso's first "interpretation" was of a painting by the seventeenth-century French painter Le Nain. In 1919, he based his own work on a painting by Renoir, the nineteenth-century Impressionist master. In the late 1920's, he was inspired by the central panel of the Isenheim Altar by Matthias Grünewald, a German painter of the late fifteenth and early sixteenth centuries who completed his masterpiece at about the same time Michelangelo completed the Sistine Chapel. "I love that painting," Picasso said of the *Crucifixion* to his friend Brassaï, "and I tried to interpret it. But as soon as I began to draw, it became something else entirely. . . ." Working from photographic reproductions of Grünewald's *Crucifixion*, Picasso translated it into his own terms, resulting in a remarkable series of drawings.

Picasso stayed defiantly in Paris during World War II while the Germans occupied the French capital. It is said that once when a German, pointing to a reproduction of *Guernica*, said to Picasso, "You did that, didn't you?" the artist replied: "No, you did." On August 24, 1944, just as Paris was being liberated from the German occupation, Picasso was to find inspiration in the work of Nicolas Poussin, the great seventeenth-century French painter. With the sound of gunfire shaking the windows of his studio, he took a reproduction of Poussin's *Bacchanale: The Triumph of Pan* and began to copy the design. At that moment, with street battles raging not far from his studio, Picasso felt attracted to the frenzy and sensuality of Poussin's painting. His interpretation of it, a

147

Women of Algiers, final version, 1955. (Oil on canvas.)
Collection of Mr. and Mrs. Victor W. Ganz

colorful gouache, is wild with excitement and, revealing many of Picasso's styles, bears a note of unmistakable optimism.

In 1947, Picasso turned to the work of the German painter and engraver Lucas Cranach, finding inspiration in the latter's sixteenth-century portrait of David and Bathsheba to produce a series of lithographs. Another work by Cranach, a portrait of a young girl, was the source of a lithograph of 1949.

Les Demoiselles des Bords de la Seine, a painting by

the nineteenth-century French painter Gustave Courbet, was the starting point for a large oil that Picasso painted in early 1950. In this interpretation, Picasso has carefully retained all the details of Courbet's realistic painting, but he has distorted them, revolutionized them, and made the painting very much his own.

Picasso has acknowledged the influence of El Greco on his elongated figures of the blue period. His deep respect for the remarkable sixteenth-century painter, whose work he had studied when a young man in Spain, is obvious in his interpretation of a work El Greco painted between 1594 and 1604 called *Portrait of a Painter*. Picasso's *Portrait of a Painter* was painted only a few weeks after he had "copied" the Courbet. Above all, he wanted to convey the "lunar light" found in the work of the master of Toledo. Once again, each detail is retained, but it is meticulously analyzed, and through the process transformed into a Picasso.

It was in 1954 that Picasso began to work on his interpretation of *The Women of Algiers*, a painting by Eugene Delacroix, the nineteenth-century French master of Romanticism. It was the first time Picasso was to do not one or a few interpretations of a single work, but a large series.

Delacroix painted two versions of this work—one in 1834, which hangs in the Louvre, and a smaller one in 1849, which is found in a museum in Montpellier. Picasso's interpretations are based on both of these versions, but Françoise Gilot, who lived with Picasso at the time, tells

an amusing anecdote concerning Picasso's relationship with the first version. In 1946, the painter made a large gift of his work to Paris's Museum of Modern Art. But before his paintings were delivered, they were temporarily placed in the Louvre. One Tuesday, when the Louvre is closed to the public, Picasso went to visit Georges Salles, director of the French National Museums, who suggested that the guards carry some of Picasso's paintings through the museum and temporarily place them next to some of the Louvre's masterpieces. It would be the first time a living painter's work would be hung in the Louvre—if only for a few minutes. Picasso agreed, and one of his works was hung next to Delacroix's masterpiece. Madame Gilot has written that Picasso often spoke of making his own version of *The Women of Algiers*, and that the painter had taken her to the Louvre on the average of once a month to see it.

It is impossible to say what made Picasso open his great dialogue with Delacroix and his painting in 1954, eight years after his own work had hung beside it in the Louvre. Perhaps it was the fact that one woman in Delacroix's painting greatly resembles Jacqueline Roque, the beautiful woman Picasso had met in 1954 and who was to become his wife.

In any case, Picasso was depressed when he threw himself into this relationship with Delacroix. Working in his old studio in the rue des Grands-Augustins, where he had painted *Guernica*, he did fifteen versions of *The Women of Algiers* between December 13, 1954 and Feb-

ruary 14, 1955. Delacroix's rich, sensuous painting—Renoir called it one of the greatest masterpieces of all art—shows three rather plump, voluptuous women in a harem. One is stretched out, reclining on the carpet, one sits cross-legged, and the third, a rose in her hair, holds a hookah in her hand. Next to them, standing and seen from the back and in profile, is a black, turbaned woman servant. Of the three seated figures, Picasso uses only two, though he combines features of all three. The first two variations were painted on the same day and are relatively close to Delacroix, capturing the tranquility and sensuousness of the harem scene. But in the third variation, done fifteen days after the first two, more radical changes take place. In painting after painting in this series of fifteen, we see the women's silks and jewels removed, revealing the roundness of their bodies; and finally their figures become masses of intertwining triangles and rectangles. The final version is strong and brilliant; it is more Picasso than Delacroix.

In August, 1959, Picasso was stimulated and inspired by a famous painting, *Le Dejeuner sur l'Herbe* (*Lunch on the Grass*) by Edouard Manet, painted in 1862. Though itself based on a work by the Italian painter Giorgione (1478(?)-1510), Manet's painting caused a great scandal when first exhibited in Paris in 1863. The setting is a clearing in a park. On the left, a picnic lunch is spread out, and alongside it are two fully dressed men with one completely naked woman. In the background, bending down, is another, scantily dressed, woman. The subject

matter, in a contemporary setting—obvious because of the manner in which the men are dressed—shocked the public, and so did the richness, boldness, and vivacity of Manet's style.

Picasso stayed in contact, on and off, with Manet's controversial work for two and a half years, until the end of 1961. The result was an enormous body of work based on *Lunch on the Grass*—27 paintings, almost 140 drawings, and three linoleum cuts. In a sense, they constitute a kind of diary of the artist during this period.

The original becomes no more than a starting point for Picasso. Manet's people are liberated, free, in the open air, with limitless space around them, and Picasso takes advantage of this freedom. He carefully explores each figure and each figure's relationship to each other figure. Though the basic composition remains for the most part, the shapes and attitudes of the figures vary. Indeed, almost all that remains of Manet are his dominant greens. Starting from Manet's controversial work, Picasso created a series full of visual joy, insight, and further evidence of his range and virtuosity.

But perhaps Picasso's most striking series of variations were those based on a Spanish painting, *Las Meninas (The Maids of Honor)*, by Velázquez, the seventeenth-century Spanish master. It is a painting that must have haunted Picasso for very many years; he first saw it when a young boy of fourteen in Madrid (it hangs in the Prado museum there), and it is probable that he saw it often. Indeed, this painting would be difficult for anyone to for-

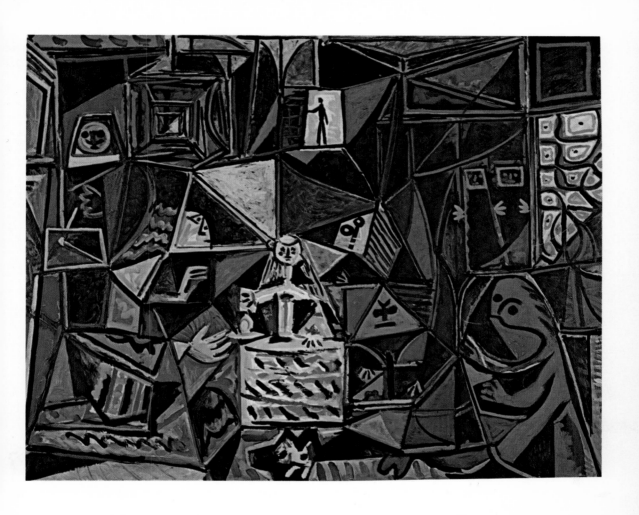

Las Meninas, 1957. (Oil on canvas.) Courtesy of The Barcelona
Museum of Art

Sylvette, 1954. (Oil on canvas.) Courtesy of The Art Institute of Chicago

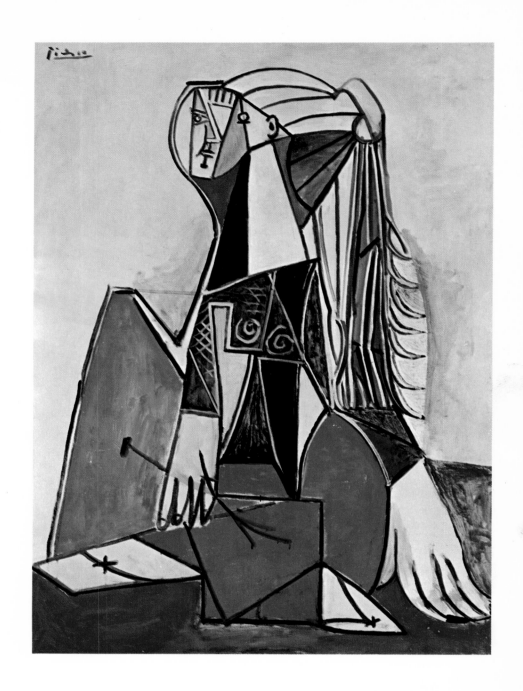

155

The Reader, 1953. (Oil on canvas mounted on plywood panel.)
Courtesy of The Art Institute of Chicago

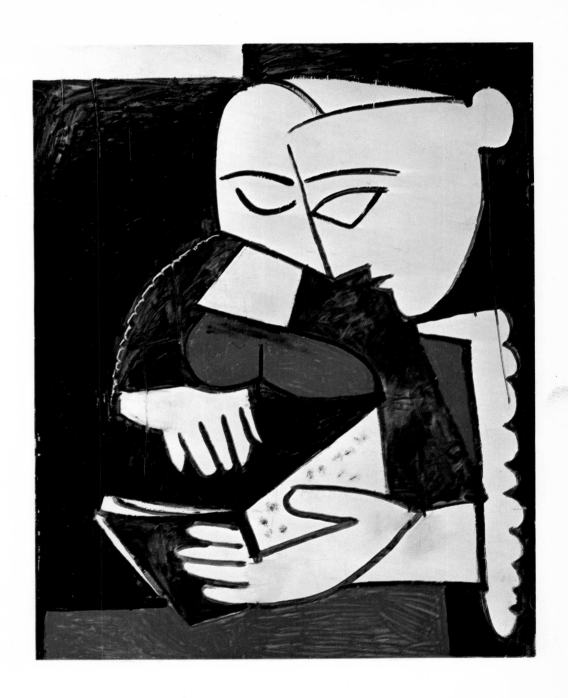

157

Still Life Under a Lamp, 1962. (Linoleum cut in color.) Courtesy of The Art Institute of Chicago

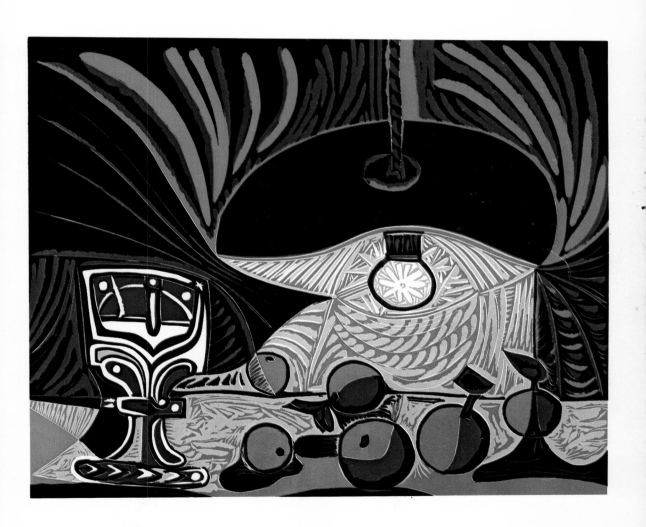

159

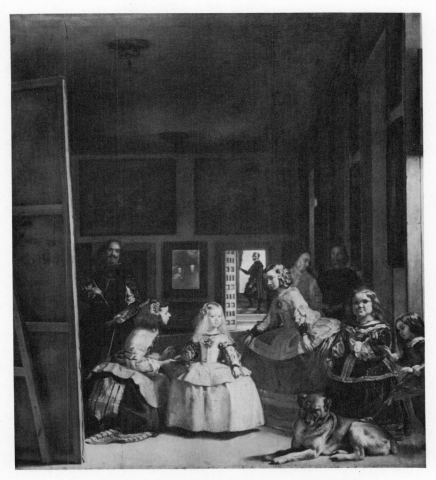

Velázquez, *Las Meninas* or *The Maids of Honor*, 1656. (Oil on canvas.) Courtesy of The Prado, Madrid

get. It is a strange work, seen from a strange perspective. Picasso's lifelong friend, Jaime Sabartes, says that when he sees it he feels he is watching a scene from a play, or perhaps puppets in a marionette show. In the center stands the Princess, the Infanta Margarita, surrounded by two maids of honor. On the far right of the painting, there is a dwarf and next to the dwarf, a child with its two hands

delicately raised. In front of them lies a large dog. Behind them stand two figures and, all the way in the back, the Chamberlain is waiting in the doorway. Next to the door is a mirror, and in it the reflection of the King and Queen, the parents of the Infanta. On the far left of the painting the artist himself, Velázquez, is poised palette and brush in hand, before a huge canvas. Because of the mirrored reflection of the King and Queen and the fact that all the other figures are facing the view, there is a curious, uncertain relationship among the painter, his models, and the spectator. Because of its singularity the painting hangs in a special room in the Prado, a mirror facing and reflecting it.

This strange painting intrigued Picasso, and about 1950 he said to Sabartes, according to the latter: "Suppose one were to make a literal copy of *Las Meninas*. If it were I, the moment would come when I would say to myself: suppose I moved this little figure to the right or to the left? At that point I would try it without giving a thought to Velázquez. Almost certainly I would be tempted to modify the light or to arrange it differently in view of the changed position of the figures. Gradually I would create a painting of *Las Meninas* sure to horrify the specialist in the copying of old masters. It would not be *Las Meninas* when he looked at Velázquez's painting. It would be my *Las Meninas*."

It was on August 17, 1957, that Picasso began work on his *Las Meninas*, thereby starting what was to be a monumental series of works. At the time, the painter and

Las Meninas, 1957. (Four details, oil on canvas.) Courtesy of
The Museum of Art, Barcelona

Las Meninas, 1957. (Four details, oil on canvas.) Courtesy of
The Museum of Art, Barcelona

Jacqueline lived in his house in the south of France. To isolate himself, to remove himself from the stream of visitors so that he might be alone with Velázquez, he moved to a nearly empty room upstairs from his usual ground-floor studio. This was to be the studio that he would, in a way, share with Velázquez, in which he would change the seventeenth-century painter's maids of honor to his own.

For the most part of more than four months, Picasso was obsessed with his work, totally absorbed by it. Even when he went downstairs, to visit with friends, to eat and to sleep, he seemed preoccupied with *Las Meninas*. For hours on end, he would remain locked in his new studio, and only Jacqueline was allowed to enter. His opening to the world was a large French window which lit the studio. From it he saw a rich, fertile garden—with palm and eucalyptus trees. And on the balcony outside the window, a pigeon house.

The view was magnificent, but at first Picasso cared for nothing but his vision of *Las Meninas* and the inspiration he would draw from that great painting. For those four months he would examine, scrutinize, question every aspect of Velázquez's work.

On the first day, August 17, he painted an overall interpretation of the painting. Then he concentrated on individual figures, largely the Infanta, removing her from the world of Velázquez and placing her in the world of Picasso. On September 6, he begins to look out of his window—pictures of the view and, above all, of the pigeons

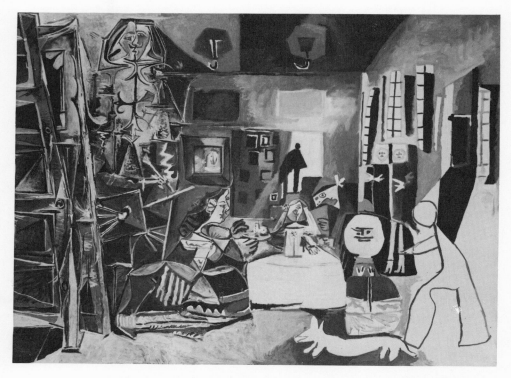

Las Meninas, 1957. (Oil on canvas.) Courtesy of The Museum of Art, Barcelona

appear until the fourteenth when he returns to interpret the Infanta and then the group again. They are becoming more and more Picasso, angular, somewhat sharp. Even the dog becomes Picasso's own dog and not the one Velázquez painted.

On October 17, the figure on the far right, the child with the gracefully raised arms, finds a place for its arms: they belong on a piano, which is where Picasso puts them.

Until the middle of November, Picasso painted his original interpretations of individuals and groups from *Las Meninas*. Then his work became more and more characteristically Picasso. He became more aware of a world outside his studio, and in early December he was painting the magnificent landscapes which he saw from his large window. On December 3, he painted a portrait of Jacqueline. His total absorption with Velázquez was coming to an end. On the thirtieth of December, he concluded his brilliant series of interpretations of one of the great works of seventeenth-century painting.

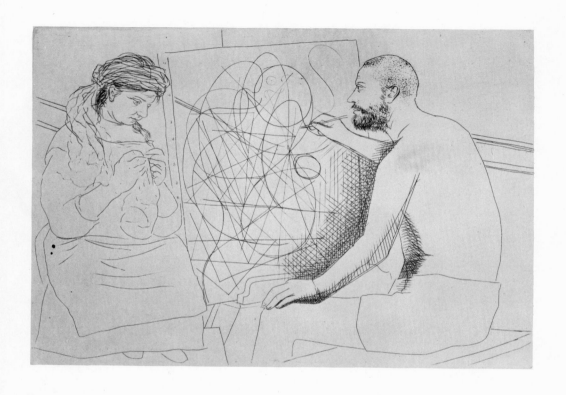

The Painter and the Model Who Knits, 1927. (Balzac, *Le Chef d'Oeuvre Inconnu,* plate 10, etching.) Courtesy of The Art Institute of Chicago

10

The Materials
of Art

Picasso cannot simply be classified as an artist by profession; he is an artist by nature, or a born artist. He doesn't wake up in the morning and say, "Well, at nine o'clock I'm going to work on a painting." This might be the way of a painter, and a good painter, too, but for Picasso art has been so integrated with life itself that he makes no distinction. Much has been written about his dazzling eyes; invariably people who meet him are startled by their power and intensity, their strength of penetration. With

Standing Man, 1907. (Wood painted yellow.) Private collection

170

these deep black eyes, he sees, envisions all matter, the ordinary objects of everyday life, as materials of art. And with his ever-active hands, he creates by transforming the ordinary into the extraordinary.

It is natural that Picasso should not have limited himself to painting and drawing alone. At the age of twenty, he turned to sculpture and, not surprisingly, he is considered one of the great sculptors of our time. In sculpture, as in painting, he has been an innovator, a revolutionary.

His early work, however, was not radical; it reflected his painting of the time, the moods of his blue and rose periods. His most famous early piece was a bronze head of Fernande Olivier, done in the cubist style, in 1909.

In 1914, he broke away from conventional sculpture and created a work called *Glass of Absinthe*. This is the first time that simple everyday objects were utilized in creating a work of sculpture. A glass was modelled in wax and was then topped with a real spoon and a lump of sugar. Then the whole was cast in bronze in six copies, each of which Picasso painted in different colors. It was during this period that all kinds of everyday objects were turned into works of art—to mold his sculptures, Picasso used cardboard, linoleum, paper, string, upholstery fringes. . . .

There followed a period of almost fifteen years during which Picasso abandoned sculpture, but in the late 1920's, he was to learn a new technique from his Spanish friend, the sculptor Julio Gonzalez—the technique of applying fire to iron and out of this came many intricate, powerful wrought-iron sculptures. At the same time he

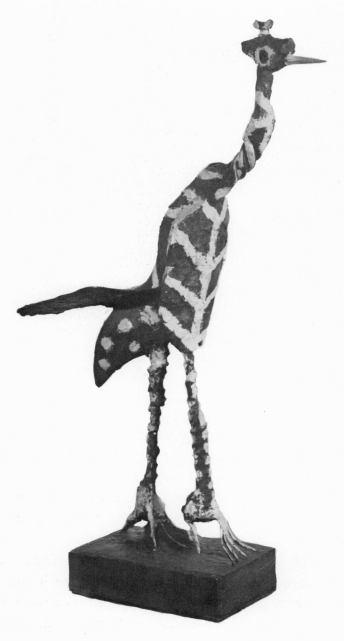

Crane, 1952. (Painted bronze after natural objects; pipe fittings, fork, child's shovel.) Collection of Mr. and Mrs. Morton G. Neumann

172

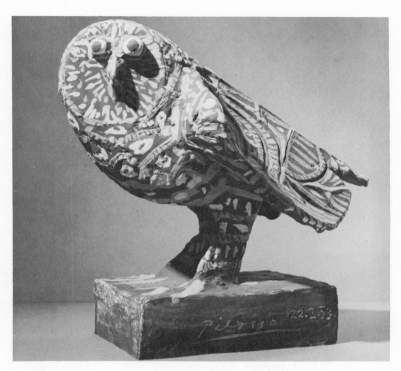

Red and White Owl, 1953. (Painted terra-cotta.) Private collection, New York

did wood carvings, and once again brought life to seemingly meaningless articles from the rubbish heap by integrating them into his work.

In 1932, Picasso bought a large house in the country and converted a barn into a sculptor's studio. There he worked on a large number of enormous heads in wet plaster and clay, beautiful works, gay and alive. These heads are distorted to emphasize expression and enrich our understanding. At the same time there are marvellous sculptures of animals, these too distorted to give them individuality.

In 1942, Picasso began work on what is his most famous sculpture, *Man with a Sheep*. It is one of his most

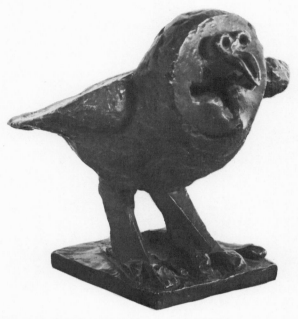

Angry Owl, 1950. (Bronze.) Collection of Mr. and Mrs. Morton G. Neumann

carefully planned and thought-out pieces of sculpture. The first idea came from an etching Picasso did of a bearded figure. He went on to do more etchings using this figure. Many months of reflection followed and resulted in almost one hundred drawings. But when he finally began work on actually modelling *Man with a Sheep*, he did so in one session, in a matter of hours, modelling very freely from little balls of clay. The sculpture as it stands now is an imposing and moving one. Over six feet high, a skinny-legged shepherd with a bald head holds a squirming lamb in his strong arms. With his right hand,

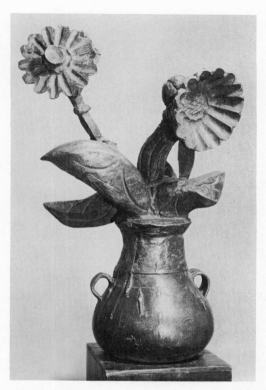

Flowers in a Vase, 1953. (Bronze.) Collection of the artist, Galerie Louise Leiris

he has caught three of the frightened animal's legs. The lamb's head is turned; in the eyes of the bearded shepherd there is a fanatical expression. When three copies of this great sculpture were cast in bronze, Picasso presented one to Vallauris, a small town in the south of France that reciprocated by making him an honorary citizen. The *Man with a Sheep* now stands in the town square; it has become part of the life of this small town.

Picasso's daring inventiveness, his ability to use so-called useless materials of everyday life and transform them into works of enduring art, continued throughout

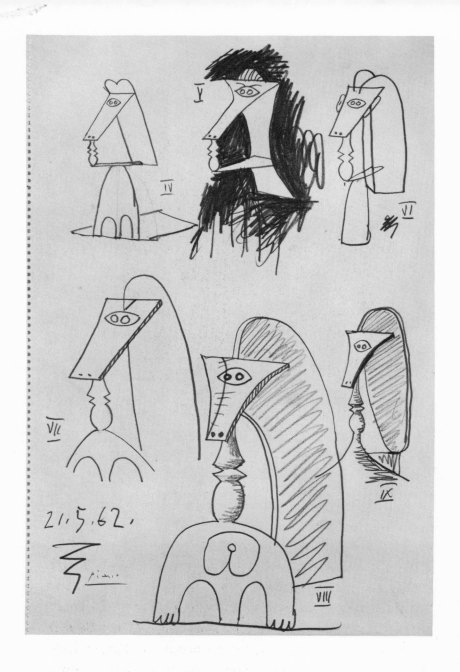

Sketches for *Chicago Sculpture*, 1962. (Pencil on paper.)
Courtesy of The Art Institute of Chicago

176

Semirectangular Platter, 1953. Courtesy of The Museum of Art, Barcelona

the forties and fifties. A sculpture called *Head of a Bull* was the result of the artist having found an old bicycle seat next to a rusted handlebar in a garage. His vision saw these ordinary castaway objects as a bull's head. His hands followed and he soldered the handlebar and bicycle seat together until they became the horned head. Picasso himself has said of this: "Everybody who looks at it . . . says, 'Well, there's a bull,' until a bicyclist comes along and says, 'Well, there's a bicycle seat.'"

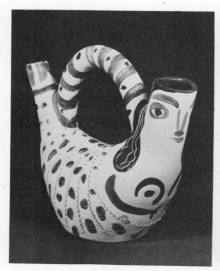 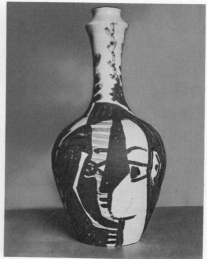

(Left) *Horn-shaped Pitcher with a Large Handle*, 1954.
Decorated with a siren
(Right) *Jar*, 1952. Decorated with two polychrome faces.
Courtesy of The Museum of Art, Barcelona

In 1950, he created what was to become the most famous goat in history—from a wicker basket, palm branches, metal tubes, terra-cotta jars, nails, and other thrown-out objects. The following year, two toy cars bottom to bottom inspired a baboon's head; a strip of metal became a tail, the handles of pitchers were transformed into ears and shoulders. The rest was modelled in wood and clay, and the final result when cast in bronze is a work both humorous and touching called *Baboon and Young*.

The list of his miraculous transformations is almost endless. He has made enchanting dolls of wood and cloth. Finding a headless and armless mannequin in an antique market, he added the head and one arm by himself—and

178

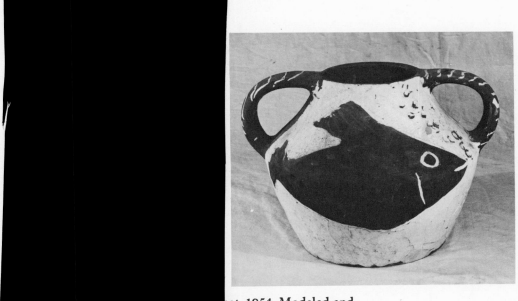

(Left) ... *...eet*, 1954. Modeled and
decorated as a bird with... ...ce
(Right) *Small-mouthed Jar with Two Handles*, 1951. Decorated
with two fish. Courtesy of The Museum of Art, Barcelona

for the second arm used a remnant from Easter Island that
had been given him as a gift. A block of wood and screws
have become a girl reading a book. Pieces of tin or wood
or bone become little birds; a splinter a blackbird, and a
piece of wood a cigar. And from a flat bone, Picasso one
day made a long-toothed comb for dogs, drawing in the
teeth of the comb and adding as a final touch a couple of
fleas.

Masks and paper cutouts from napkins, too, are part
of Picasso's repertoire. When a friend's dog was lost,
Picasso fashioned daily paper-napkin dogs as compensation
for the loss. Finally, while on the beach, Picasso loves to
gather pebbles and transform them according to his fan-

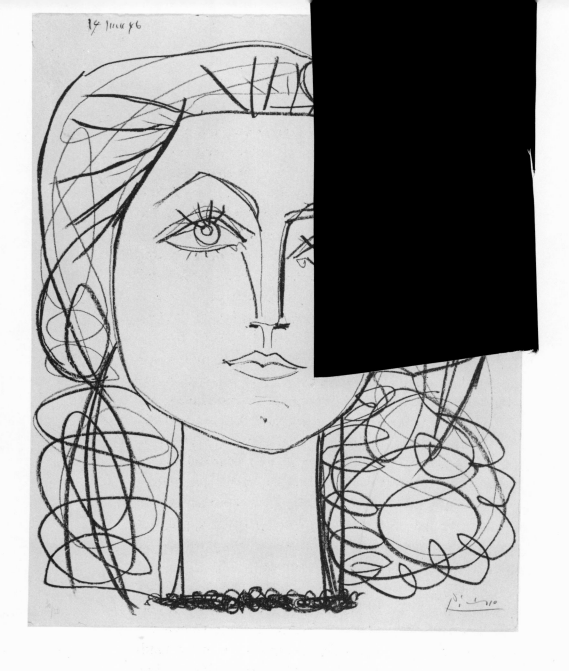

Francoise, 1946, (Lithograph.) Courtesy of The Art Institute of Chicago

180

tasy. A round pebble might become an owl and a triangular one a bull or a goat. Working with any instrument at hand, he finishes them off with a very sharp-pointed pair of scissors. The results of all this are not great, important works of art; but they are witty and imaginative, more evidence of the totality of Picasso as an artist.

In the 1960's, he turned to larger works of sculpture, often using sheet metal which he then painted. The model for these was cut out of paper or cardboard, after which Picasso folded it to show the artisans who finally worked on the metal the forms that were required. In 1964, Picasso executed his most important piece of monumental sculpture, having been asked by the architectural firm of Skidmore, Owings and Merrill to design a monument for Chicago's Civic Center. He agreed and donated a model of a woman's head, in welded steel, to serve as the basis for the sculpture. The final work was unveiled in the summer of 1967. The gigantic head—sixty feet high—dominates the plaza in front of the Civic Center. As the viewer walks around, examining it from every angle, and from all distances, it takes on heroic proportions—of strength, of wisdom and, for many, of peace.

Closely related to sculpture is another one of Picasso's seemingly inexhaustible interests—that of ceramics, or pottery. In 1946, on a visit to friends, he was shown the Madoura pottery in Vallauris, the same town in the south of France to which he gave his *Man with a Sheep*. The owners of the pottery suggested he try his hand at modelling, which he did without too much interest. A year later,

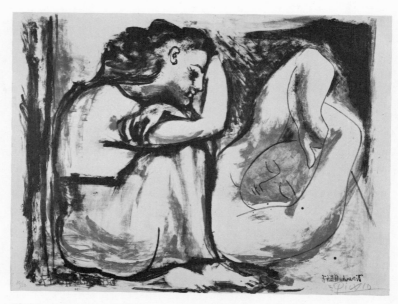

Sleeper and Seated Girl, 1947. (Lithograph.) Courtesy of The Art Institute of Chicago

however, he returned and was delighted to see that what he had carelessly modelled the year before had been fired. The procedure intrigued him, and he decided to work at it seriously.

The results have been far-reaching, revealing another aspect of Picasso's talent as well as reviving the art of pottery in Vallauris. Because of the red clay in the vicinity and the pines of a nearby forest (which provided a good acid fire) the town had for centuries—before the times of the Romans—been known for its ceramics. But interest in the pottery of Vallauris had diminished after World War II, and only through the efforts of Picasso has it again grown.

The clay and its sensitivity to the touch were a challenge to Picasso. Working in this prehistoric art, he would

Visage, 1928. (Lithograph.) Courtesy of The Art Institute of
Chicago

watch the effects of the almost miraculous combination of earth, water, air, and fire, bringing his own unique genius to it.

He studied the new problems he had to face carefully; at first working in the traditional manner and then learning to what extent he could make this field his own by constant experimentation. Everything was new to him, and he marvelled at the reactions of various color to the flame, to the changes in texture, form, and design brought about by the exposure of the clay to the fire. Every aspect fascinated him. At first he worked on plates, flat surfaces, which he decorated, in vivid colors, with birds and fish and bullfight scenes. Then he tried his skill at different shapes, creating fanciful pigeons and bulls and a world of imaginary animals. Tiles became owls, jugs were molded in the shape of a goat, a teapot took the form of a bird, and vases acquired the contours of women. With his sensitive hands, he created ceramic masks, flowers, and radiant still lifes.

The overall feeling of Picasso's pottery is one of gaiety and lightness and joy. Vallauris today is a booming tourist attraction, with shop after shop filled with imitation Picasso pottery. To get the best idea of the mediocrity of these imitations, one need only compare it with Picasso's own glowing work. This combination of earth, fire, air, and water, managed with the genius of Picasso, has given a new meaning to the art of ceramics.

In the field of graphic arts—those original works which can be reproduced in limited quantities—Picasso too has proven to be master. From his early childhood, the

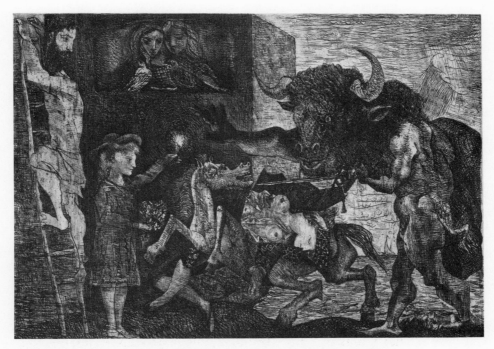

Minotauromachy, 1935. (Etching.) Courtesy of The Art Institute of Chicago

seemingly simple drawing of a line has been a means of expression for him. In Malaga, he would draw horses and bulls on the sand; at home he would cut out figures with scissors and paper. As he demonstrates in his great paintings, he is a superb, unequalled draftsman who with a single continuous line could express a world of emotions, through the means of any available instrument—pencil, pen, india ink or charcoal, or colored crayons.

· His brilliant achievement in the graphic arts is an extension of this: instead of drawing on paper or on canvas he has mastered the techniques—and gone beyond ordi-

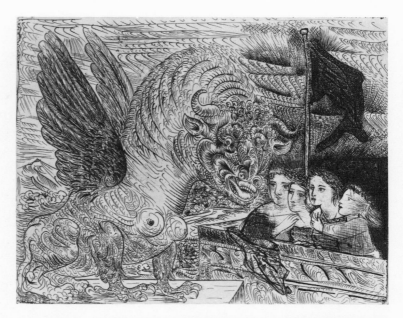

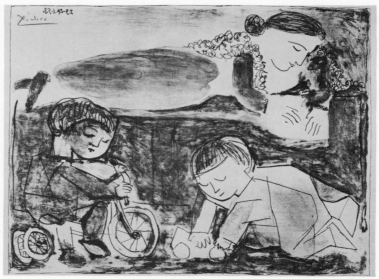

(Top) *Four Children Viewing a Monster*, 1935. (Etching.)
(Below) *Games and Reading*, 1953. (Lithograph.) Courtesy of
The Art Institute of Chicago

nary ones—of drawing on copper, on zinc, and on stone with astounding effect. His first etching—drawing with a needle on a copper plate—was done when he was but eighteen years old. It was not a distinguished work, but by 1904, having learned the technique from his Spanish friend Ricardo Canals, the twenty-three-year-old artist had already created a masterpiece. It is called *The Frugal Repast,* and it shows a blind man, his head turned away and his long, sensitive fingers holding tenderly onto his female companion, seated before an almost barren table —a bottle, two glasses, one empty plate, and a piece of bread are shown. In its pathos and compassion for human misery it echoed the paintings of this, his blue period.

The following years, during his rose period, Picasso worked on etchings of acrobats and wandering circus people. To produce a soft, velvety line, he used a technique called drypoint. For this a sharp-pointed hard-steel needle is used to produce furrows causing metal shavings (called a burr) on the copper that are retained to give this soft effect. In 1912, he did thirty etchings and drypoints in the cubist style, with great success.

Between 1905 and 1915, he experimented with the relatively simple technique of the woodcut, cutting the design into a block of wood, but he found this too limited for his purpose. And in 1919 he first tried lithography, drawing on stone or zinc, but at that time he found it did not respond to his artistic needs.

During the period between 1927 and 1931, Picasso turned to book illustration, the outstanding works being

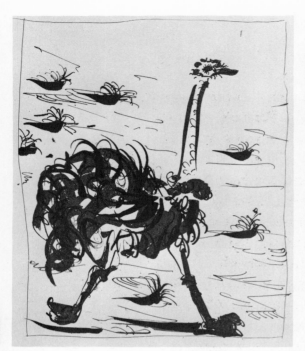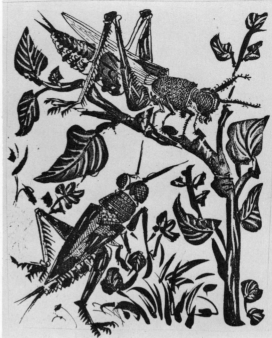

Two illustrations from Buffon's *Histoire Naturelle*, 1942.
(Left) *Ostrich*, (right) *Grasshopper*. (Raised ground etching.)
Courtesy of The Art Institute of Chicago

the 1927 illustrations for Balzac's *Le Chef-d'oeuvre Inconnu* and thirty brilliant classical illustrations for Ovid's *Metamorphoses*.

In the early thirties, too, he did a series of etchings in the neoclassic style on the theme of the sculptor and his model; forty of them were completed in 1933, with sometimes as many as four achieved in one day. In 1933, the surrealist magazine *Minotaure* was founded, and for it Picasso executed twelve powerful etchings of the mythical monster—a mixture of man and bull. These show the fierce figure asleep, near death, and in states of joy. There followed the next year many scenes of bullfights,

including etchings of a woman matador. The etchings of these years lead directly to one of Picasso's greatest works in any medium—*Minotaurmachy*, which he executed in 1935. A 19½ x 17-inch etching, it depicts a symbolically complicated but tremendously powerful scene. There are two main characters: a young girl, a figure of purity, a flower in one hand and a lighted candle in the other; and the enormous menacing figure of the Minotaur, who appears to be trying to extinguish the candle. Between the two is a disembowelled horse, on its back the limp body of a female matador. On the side, a bearded man climbs a ladder; watching the scene are two women at a window and on the sill, two doves. It is impossible to explain the "meaning" of this work, but it is also unnecessary. It is a shattering emotional experience and a great work of art. Two years later Picasso used some of the same characters and the same themes in his *Guernica*.

In the following year, Picasso began work on illustrations for a book that was to be published in 1942. The book was Buffon's *Histoire Naturelle*, a bestiary, and for this work the artist explored and experimented with a number of new techniques, principally drypoint and sugar aquatint. This latter process, which involves melting a lump of sugar in hot water and then mixing it with other substances—gouache and gamboge—gives a richer tonal effect, and responds more to varieties of touch. Experimenting for different effects with pen, brush, and thumbprint, Picasso produced a delicate, humorous, and charming imaginary zoo which included a wolf, a lizard,

an ostrich, a crayfish, and a ram. By going beyond and combining ordinary techniques, the artist had produced effects never before achieved.

During the 1940's, Picasso illustrated many books, and after the war, in 1945, he returned to lithography, which he had found less than satisfactory in his first attempts. This time he did so under the initial tutelage of Fernand Mourlot, whose workshop in Paris was considered the finest in the world. Picasso enjoyed working at Mourlot's, among the skilled artisans of lithography. He learned from these men who were to print his work, and he challenged them to print what they would have thought impossible, for once again he applied his own special and original techniques. Time and again he was told that his unconventional work on stone could not be printed; and time and again he proved that it could be printed. Between 1945 and 1949, he had done one hundred and eighty lithographs; by 1968, he had completed nearly five hundred, some of them in six or eight colors.

In 1958, Picasso brought to new life the simplest of graphic art forms, the linoleum cut, the cutting of a design in soft linoleum that is the introduction to art for most schoolchildren. By again experimenting, by indeed inventing a technique of single-block multicolored linocuts, Picasso produced works of unheard-of beauty in the medium over a ten-year period beginning in 1958.

In the 1960's, Picasso settled permanently in Mougins, in the south of France. He no longer wanted to travel; he wanted to work in the mild climate and tranquility of

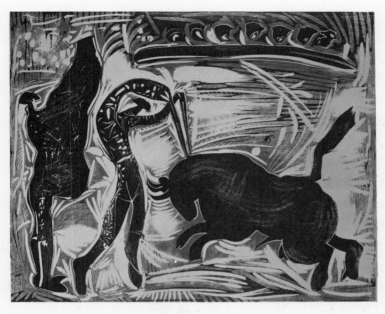

The Banderillos, 1959. (Linoleum engraving.) Courtesy of The Art Institute of Chicago

the Mediterranean. Always eager to see proofs of the prints of his works as quickly as possible, he largely abandoned lithography—Mourlot's workshop in Paris was too far away—and turned to etching again. His printers were two unusually gifted young men, Aldo and Piero Crommelynck. To accommodate Picasso, these two brothers from Paris brought a handpress to Mougins, whereby Picasso could quickly see the proofs of his work. Whenever he felt like doing engravings he would summon the Crommelyncks to Mougins. But nothing prepared them for what was to happen in March, 1968. It was Aldo Crommelynck, in Paris, who received the call to come

south. It was assumed to be a routine call. But the eighty-six-year-old painter was in a state of creative passion. Day after day, for almost seven months, he threw himself into work. Combining every technique of etching, drypoint, and aquatint, he created 347 engravings between March 13 and October 5. Working with almost inhuman energy, he sometimes turned out as many as seven engravings a day.

The results were publicly shown to a startled world in December, 1968, when an exhibition entitled simply *347 Engravings* opened simultaneously in Paris and in Chicago. In the words of the Crommelyncks, these engravings "form a kind of diary in which every day (except for some rare interruptions) he inscribed his thoughts on copper." These works are dazzling in their variety, in their never-ending exploration. Themes of his life recur: Spain and Spaniards, circuses, horses, the painter and his model, voluptuous, distorted, and beautiful women—and above all the joys of love.